Shigenobu Kobayashi is the founder and director of the Nippon Color & Design Research Institute. He is a graduate of Hiroshima College of Technology and received his master's degree from Waseda University for his work in the field of color psychology.

Since founding the institute in 1966, he has been a leader in research on color psychology. A detailed discussion of his theories is available in English in *Color Research and Application* (vol. 6, No. 2, Summer 1981) in an article entitled "The Aim and Method of the Color Image Scale."

He is also an active participant in meetings of the International Color Association and a lecturer at the Musashi Institute of Technology.

The Nippon Color & Design Research Founded in 1966, the institute is a leader in its field, acting as a color and design consultant to over 300 major Japanese corporations in fields as diverse as automobiles, home appliances, cosmetics, food, department stores, and home construction.

The institute's patented Color Image Scale is the centerpiece of its 'ogy of color. In addition the institute has developed Color Image Scale and a large information data base nd consulting projects.

unkyo-ku, Tokyo, 113-0033, Japan

COLOR IMAGE SCALE

by Shigenobu Kobayashi

Translated by Louella Matsunaga

KODANSHA INTERNATIONAL
Tokyo • New York • London

Originally published in 1990 in Japanese as *Color Image Scale* by Kodansha, Ltd.

Distributed in the United States by Kodansha America. Inc., 114 Fifth Avenue, New York, NY 10011, and in the United Kingdom and continental Europe by Kodansha Europe, Ltd., 95 Aldwych, London WC2B 4JF. Published by Kodansha International, Ltd., 17-14 Otowa 1-chome, Bunkyo-ku, Tokyo 112, and Kodansha America, Inc.

Printed in Japan
First edition 1991
98 99 00 10 9 8 7 6 5

ISBN: 4-7700-1564-X

Library of Congress Cataloging-in-Publication Data

Kobayashi, Shigenobu. 1925-
 Color Image Scale / by Shigenobu Kobayashi :
translated by Louella Matsunaga. —1st ed.
 p. cm.
 Originally published in 1990 in Japanese.
 Includes indexes
 1. Color—Psychological aspects. I. Title.
BF789.CK579 1991
701'.85—dc20
 91-32102
 CIP

Contents

Introduction

Ours is an age of increasing sensitivity to color. But what meanings are conveyed by the colors that surround us in everyday life? If we could grasp their real meanings, perhaps we would be able to use them more effectively. The first step toward a more effective use of color is to systematize and classify colors through key words that express their meanings and through images that express the differences between them.

For single colors this can be done by arranging them sequentially according to their place in the spectrum. But this is not possible for color combinations, and though it is obvious at a glance that different color combinations convey different images, the problem is how to classify them in a systematic way. This book introduces the Color Image Scale—a data base developed at the Nippon Color & Design Research Institute for systematically classifying color combinations.

The scale was developed by using 130 basic colors to make different three-color combinations. We then input into our computer 180 image words that relate to the ways in which people perceive colors, and also data on which words were associated with which colors. From this we generated a 130-page data base that shows the images associated with the color combinations created by using each of the 130 basic colors. These images are

links between the worlds of objects (e.g., fashion, interior design) and lifestyles.

I believe that this classification of colors based on images is the key to understanding the way in which color combinations are perceived, and that this systems opens a path to the future, when sensitivity to color will continue to grow. I hope, therefore, that this book will have a deep and lasting appeal.

I would like to take this opportunity to express my profound gratitude to Mr. Junichiro Matsuoka of Kodansha, Ltd. for his interest in this approach and for all his help and encouragement in the publication of this book. And I must also thank the staff of the Nippon Color & Design Research Institute, in particular, Katsura Iwamatsu, Keiko Yoshida, Hiroko Suzuki, and Akihiko Suzuki, for their assistance in this project.

Shigenobu Kobayashi

How this book works

In what way and in what situations should you use colors? In this book, we address this issue by focusing on the images of colors, as detailed in paragraphs 1 to 5 below.

1. Understanding the interrelationships between colors

Colors do not exist as single entities. It is essential to examine carefully the different images conveyed by variations in hue and tone.

→ For example, if you want to know what image is conveyed by the color brown, first consult the Hue and Tone Sytem table on pp. 6–7 and find the shade of brown closest to the one you have in mind. Then turn to the page for that shade.

2. Examining differences in image

How do the images conveyed by colors of a red hue change as the tone changes? And for colors of the same tone—for example, vivid tones—how does their image change with a change in hue?

→ For an overview of the images conveyed by each color, consult the single color image scale on p. 9. Further details are given in the key word image scale on pp. 12–13.

→ Alternatively, the image word list on pp.14–17 can be used as a data base to find the color combinations appropriate to the image you are seeking to project.

3. Checking the characteristics of individual colors

If you want to project a fashionable image, what color should you choose? Clear or grayish? Purple or red purple in hue? Light or light grayish in tone?

→ If you have already decided on the word that goes with the image you are looking for, you can find the colors corresponding to that word in the index on pp. 156–160.

→ if you have only a vague idea as to the image you wish to project, consult the separate image genre index on pp 152–155 first. Alternatively, check page 11 to see which color combination is closest to the image you are looking for, and then consult the index.

4. Color combinations—learning how to look at and use them

The 130 colors shown in this book and the nine different color combinations shown for each color each have their own individual character and also their own charm and beauty. As far as the color combinations are concerned, the first point to consider is whether you want to create a unified effect through the use of a gradation of hues or tones, or whether you want to make your chosen color stand out, in which case a color combination using contrasting colors would be more effective.

→ for more details on color combination techniques, please consult *A Book of Colors* (Kodansha International, Ltd., 1987).

→ For an overview of the images conveyed by different color combinations, please refer to the Color Combination Image Scale on p. 11.

5. Practical applications of color images

On each page data is included to help you find which color, or color combination, is appropriate to the image you wish to convey. For example, vivid purple (P/V) is used a great deal in fashion, but not in interiors. For interiors the basic color is a light grayish tone of yellow red (YR/Lgr).

→ For each color, the fields in which it has been most widely used to date are marked with one or more stars (★) for easy reference.

→ Data on taste and lifestyle has also been included, to show which colors appeal to what sort of people. Further details on our approach to this issue can be found on pp. 17–20.

How to look at the data

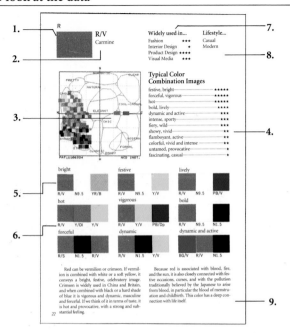

Within the example diagram:

1. R
R/V
Carmine

2.

7. Widely used in...
Fashion	★★★
Interior Design	★
Product Design	★★★★
Visual Media	★★★

Lifestyle...
Casual
Modern

8.

Typical Color Combination Images
festive, bright	★★★★★
forceful, vigorous	★★★★★
hot	★★★★★
bold, lively	★★★★
dynamic and active	★★★
intense, sporty	★★★
fiery, wild	★★★
showy, vivid	★★
flamboyant, active	★★
colorful, vivid and intense	★★
untamed, provocative	★
fascinating, casual	★

3.

4.

5.
bright — R/V N9.5 YR/B
festive — R/V N9.5 Y/V
lively — R/V N9.5 PB/V
hot — R/V Y/Dl Y/V
vigorous — R/V Y/V PB/Dp
bold — R/V N9.5 N1.5

6.
forceful — R/S N1.5 R/V
dynamic — R/V N1.5 Y/V
dynamic and active — BG/V R/V N1.5

Red can be vermilion or crimson. If vermilion is combined with white or a soft yellow, it conveys a bright, festive, celebratory image. Crimson is widely used in China and Britain, and when combined with black or a hard shade of blue it is vigorous and dynamic, masculine and forceful. If we think of it in terms of taste, it is hot and provocative, with a strong and substantial feeling.

Because red is associated with blood, fire, and the sun, it is also closely connected with festive occasions, curses, and with the pollution traditionally believed by the Japanese to arise from blood, in particular the blood of menstruation and childbirth. This color has a deep connection with life itself.

9.

22

1. Theme color
2. Name of color
3. Main color combinations and their image patterns
4. Typical color combination images
5. Examples of three-shade color combinations (nine examples)
6. Color reference code (hue/tone)
7. Fields in which the theme color is most widely used
8. Taste/lifestyle checkpoint
9. Hints on how to use this color

The data for each color is set out on pp. 22–151 and structured as shown in sections 1–9 in the example above.

1. Theme color
One page is devoted to the data on each of the 130 colors in this book.
→ For a complete table of all colors used, see pp. 6–7.

2. Color name
The code for the hue and tone are given at the top, with the name of the color underneath.
→ See table on pp. 6–7

→ For an explanation of the Hue and Tone System, see p. 8. Most of the names given are in everyday use, and can cover a range of shades.

3. Main color combinations and their image patterns

The color image patterns that can be achieved with the theme color are arranged in order to be understood at a glance.

For an explanation of this system, see pp. 8–13.

The 180 image word data base is found on pp. 14–17.

4. Typical color combination images

From the 180 Image Word Data Base we have chosen the words that most accurately represent the special characteristics of the theme color (usually about nine words). The frequency with which the theme color is used in color combinations to project a given image is shown by the number of stars (★) shown next to each adjective. There are five levels of frequency:

★★★★★	most often
★★★★	very often
★★★	often
★★	quite often
★	sometimes

No star: this image does not have a high rating in the data but is included for reference purposes.

5. Examples of three-color combinations (nine examples)

Nine of the images with the highest rating have been selected from the color combination data base. The numbers before the image words refer to the 180 Image Word Data Base on pp. 14–17. For colors with a low frequency of use, we have made new color combinations. The image words for these combinations are given in brackets.

6. Color reference code (hue/tone)

Underneath each color a reference code is given denoting hue and tone (see table on pp. 6–7).

7. Fields in which the theme color is most widely used

We used data obtained from market research conducted in Japan by our institute between 1985 and 1988. The items in the survey were: fashion (women's and men's sweaters); interior design (curtains); product design (automobiles, household electrical goods); and visual media (mainly Japanese printing ink sample books).

Many stars mean that the theme color is very often used in the field, no stars indicates a low frequency of use. The frequency of use indicated by numbers of stars is shown below. Please consult individual color tables for examples.

★★★★	very often used
★★★	often used
★★	quite often used
★	sometimes used

8. Taste/lifestyle checkpoint

Lifestyle is intimately connected with taste in colors. Of the eight types of taste and lifestyle, the ones that fit the theme color best are shown in order of ease of use. The data for this section was obtained from the annual survey of Japanese consumer tastes, *Season Image Report*, published by the Nippon Color & Design Research Institute.

→ For an explanation of the taste/lifestyle categories, see pp. 17–20.

Some widely used basic colors can fit into any type of lifestyle. Our data allows you to check what kinds of people (in terms of taste) your chosen colors will appeal to.

9. Hints on how to use a color

Please consult the appropriate section for your chosen color.

The colors used in this book (Hue and Tone System)

tone		hue →	R	YR	Y	GY	G
vivid	V	vivid tone	P.22	P.34	P.46	P.58	P.70
	S	strong tone	P.23	P.35	P.47	P.59	P.71
bright	B	bright tone	P.24	P.36	P.48	P.60	P.72
	P	pale tone	P.25	P.37	P.49	P.61	P.73
	Vp	very pale tone	P.26	P.38	P.50	P.62	P.74
subdued	Lgr	light grayish tone	P.27	P.39	P.51	P.63	P.75
	L	light tone	P.28	P.40	P.52	P.64	P.76
	Gr	grayish tone	P.29	P.41	P.53	P.65	P.77
	Dl	dull tone	P.30	P.42	P.54	P.66	P.78
Dark	Dp	deep tone	P.31	P.43	P.55	P.67	P.79
	Dk	dark tone	P.32	P.44	P.56	P.68	P.80
	Dgr	dark grayish tone	P.33	P.45	P.57	P.69	P.81

The 120 chromatic colors and 10 achromatic colors used in this book are arranged below by tone (along the vertical axis) and hue (along the horizontal axis)

BG	B	PB	P	RP	Neutral	
P. 82	*P. 94*	*P. 106*	*P. 118*	*P. 130*	N9.5	
						P. 142
P. 83	*P. 95*	*P. 107*	*P. 119*	*P. 131*	N9	
						P. 143
P. 84	*P. 96*	*P. 108*	*P. 120*	*P. 132*	N8	
						P. 144
P. 85	*P. 97*	*P. 109*	*P. 121*	*P. 133*	N7	
						P. 145
P. 86	*P. 98*	*P. 110*	*P. 122*	*P. 134*	N6	
						P. 146
P. 87	*P. 99*	*P. 111*	*P. 123*	*P. 135*	N5	
						P. 147
P. 88	*P. 100*	*P. 112*	*P. 124*	*P. 136*	N4	
						P. 148
P. 89	*P. 101*	*P. 113*	*P. 125*	*P. 137*	N3	
						P. 149
P. 90	*P. 102*	*P. 114*	*P. 126*	*P. 138*	N2	
						P. 150
P. 91	*P. 103*	*P. 115*	*P. 127*	*P. 139*	N1.5	
P. 92	*P. 104*	*P. 116*	*P. 128*	*P. 140*		*P. 151*
P. 93	*P. 105*	*P. 117*	*P. 129*	*P. 141*		

Single Color Image Scale

Hue and Tone System
(for hue and tone table, see pp. 6–7)

Colors can be divided into two categories: chromatic, such as red, orange, or yellow, and achromatic, such as white, gray, or black. If chromatic colors are arranged in a gradation of hues, R-YR-Y-GY-G-BG-B-PB-P-RP-R, a circle of colors (or hues) is formed. Here, ten hues are used as a base, in accordance with the JIS (Japanese Industrial Standard).

Each hue may be bright or dull, showy or sober. In other words, each hue has a number of tones. The tone of a color is the result of the interaction of two factors: brightness, or value, and color saturation, or chroma.

Single color images

We have developed the Color Image Scale in order to make clear the meanings or images of each individual color, and to enable assessment and comparison of colors. In the Single Color Image Scale on the following page, 130 colors (120 chromatic colors and ten achromatic colors) have been arranged according to their hue and tone (ten hues and twelve tones).

All the colors have been positioned along three axes: warm-cool, soft-hard, clear-grayish. Colors of the same tone are arranged in order of hue, starting from red at the left of the scale. The lines linking colors of the same tone show the range of images that tone can convey.

The achromatic colors form an arc in the cool half of the scale, running along the soft-hard axis, from white at the top (soft) through the various grays to black at the bottom (hard).

How to look at the Single Color Image Scale

The further the distance between colors on the scale, the greater the differences between their respective images. So, for example, red, black, and white are far apart on the scale and have very different images. Conversely, colors that are close to each other on the scale have similar images.

Calm, grayish colors may be found in the center of the scale, while clear colors with correspondingly clear-cut images may be found around the edges. The calmest color of all is the purple at the center; it is neither warm nor cool, soft nor hard.

Taking the zero at the center of the scale as the starting point, as you move out toward the edges of the chart the images of the colors become stronger: 1 = fairly, 2 = very, 3 = extremely.

For vivid tones, the image varies dramatically according to the hue. Conversely, dark grayish tones with low chroma, show little variation in the images associated with different hues.

Vivid tones
V Vivid, bold, clear. Full of life, attract attention. Sharp and lively.
S Slightly duller than vivid tones. Sturdy and substantial, convey a practical feeling.

Bright tones
B Bright and clear, like sparkling jewels reflecting the light. Convey images with a sweet flavor.
P Pale tones, create a dreamlike atmosphere. Pretty, sweet, and dreamy.
Vp Light colors that convey a feeling of softness and delicacy.

Subdued tones
Lgr Simple, gentle, quiet colors.
L Convey a mild and charming image.
Gr Little pigmentation, simple, quiet and elegant.
Dl Quiet and sophisticated, old-fashioned.

Dark tones
Dp Deep tones, full-bodied, tasteful. Convey a substantial feeling.

Single Color Image Scale

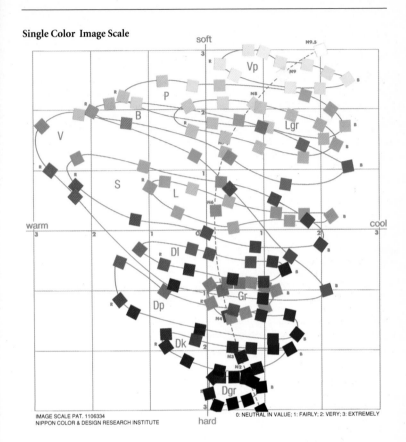

IMAGE SCALE PAT. 1106334
NIPPON COLOR & DESIGN RESEARCH INSTITUTE

0: NEUTRAL IN VALUE; 1: FAIRLY; 2: VERY; 3: EXTREMELY

Dk Dark, but with a subtle tinge of hue. Resonant colors, convey an atmosphere of stability.

Dgr Close to black, severe, serious, austere. Convey a feeling of precision.

The images of achromatic colors

All of these have a cool image. White is refreshing, while black is heavy and severe. The grays range from light to dark and can readily be used to convey a calm feeling. As achromatic colors have no hue, they provide an effective foil to chromatic colors.

Color Combination Image Scale

Until now, there has been no way to order color combinations colorimetrically, but if we use the same co-ordinates that we use for single colors to classify color combinations, from the point of view of their psychological significance, then an infinite number of color combinations can be ordered on an image scale. Since three-color combinations can express subtle differences in image, these are the basic units of this system.

An overview of the images of color combinations

The Color Combination Image Scale on p. 11 shows the subtle differences that exist between different color combinations. Within the limits of the sample of combinations shown, an overview of the images of color combinations can be obtained at a glance. The word beneath each combination expresses the image associated with it.

By consulting the Key Word Image Scale and using this Color Combination Image Scale as a base, the different color combinations can be ordered according to whether they are warm or cool, soft or hard, clear or grayish.

Within this overall system, color combinations that resemble each other are grouped together into categories, such as pretty or casual, so that each color combination's distinguishing characteristics are easier to see, and their images can be differentiated with greater precision.

From colors to key words, from key words to colors, how to grasp the image

This image scale was created with the aim of presenting the differences between images clearly in a visual form, on the basis of our research on colors. As far as possible, our strategy has been to break down in an objective and sensitive way the abstract areas of the meanings of objects, product images, and individual taste, and to transpose the images of colors into words.

How to look at the Color Combination Image Scale

Color combinations that are far apart have opposing images, those that are close together have similar images. Color combinations on the periphery of the scale use mainly clear colors in contrasting combinations (see note 1), while color combinations with a calm image, using gradations of grayish colors (see note 2), are concentrated in the center of the scale. This scale should be viewed in conjunction with the key word image scale on the following page.

For concrete examples of each image, please consult the index on pp. 152–156.

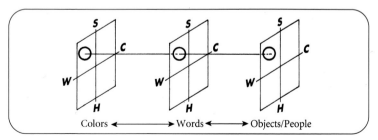

Colors ◀——▶ Words ◀——▶ Objects/People

Color Combination Image Scale

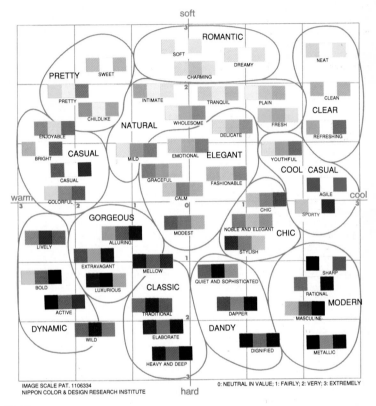

soft

ROMANTIC
SOFT
DREAMY
NEAT
PRETTY SWEET
CHARMING
PRETTY
CLEAN
INTIMATE TRANQUIL PLAIN
CHILDLIKE
CLEAR
NATURAL WHOLESOME FRESH
ENJOYABLE DELICATE REFRESHING
CASUAL MILD EMOTIONAL ELEGANT YOUTHFUL
BRIGHT COOL CASUAL
CASUAL GRACEFUL FASHIONABLE
AGILE
COLORFUL CALM
warm CHIC SPORTY **cool**
GORGEOUS
MODEST NOBLE AND ELEGANT CHIC
LIVELY ALLURING STYLISH
EXTRAVAGANT MELLOW
QUIET AND SOPHISTICATED SHARP
BOLD LUXURIOUS CLASSIC RATIONAL
MODERN
ACTIVE TRADITIONAL DAPPER MASCULINE
DYNAMIC DANDY
WILD ELABORATE DIGNIFIED METALLIC
HEAVY AND DEEP

IMAGE SCALE PAT. 1106334
NIPPON COLOR & DESIGN RESEARCH INSTITUTE

hard

0: NEUTRAL IN VALUE; 1: FAIRLY; 2: VERY; 3: EXTREMELY

Notes

1 A color of a contrasting tone is placed between two colors of the same tone in order to separate them—a weak tone between two strong tones or a strong tone between two weak tones.

2 Subtle gradations of hue and tone.

3 For further details of the color combination technique, please consult *A Book of Colors* (Kodansha International, Ltd., 1987).

KeyWord Image Scale

Differences between key words, differences between images

A common feeling runs through the images that people hold of colors. On the basis of research linking adjectives associated with these images and colors, we have developed the Key Word Image Scale. Three axes have been used on the scale, as described on p. 8, in order to obtain an objective assessment uninfluenced by value judgments based on likes or dislikes, or by our current environment.

Broadly speaking, the key words in the warm-soft area of the scale have an intimate feeling, and convey a casual image, while those in the warm-hard section have a dynamic character. The key words in the cool-soft section have a clear feeling and suggest a good sense of color, while those in the cool-hard section conveys an image of reliability and formality.

To make the key words easier to understand, key words that convey a similar image have been grouped together into broad categories. The names of these categories have been taken from terms used in fashion, such as "elegant" or "romantic."

The words in this image scale should not be taken as applying to just one point on the scale. The images they convey tend to have a ripple effect, spreading over a wide area, but the image gradually becomes weaker as it spreads. The words at the edge of the scale should, however, be taken at face value.

Words and colors that are located at the same point along the warm-cool and soft-hard axes have the same image. It is the image that forms the link between the word and the color.

These image words do not apply only to colors. In their broadest sense they can be applied to shapes, patterns, materials, interior design, fashion, and product design as a way of ordering images from a psychological point of view.

Notes

1 Six words in our data base have a broad application and are difficult to locate precisely on the image scale: grand, intrepid, salty, aqueous, pastoral, and dewy. Excluding these, 174 words are shown on the scale.

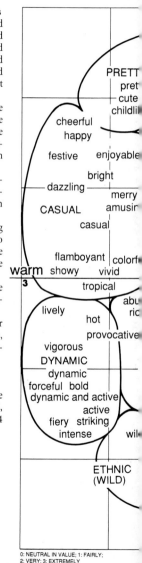

PRETT
pret
cute
childli

cheerful
happy

festive enjoyable

bright

dazzling
merry
CASUAL amusir
casual

flamboyant colorf
warm showy vivid
3 tropical
abu
lively ric
hot
provocative
vigorous
DYNAMIC
dynamic
forceful bold
dynamic and active
active
fiery striking
intense wil

ETHNIC
(WILD)

0: NEUTRAL IN VALUE; 1: FAIRLY;
2: VERY; 3: EXTREMELY

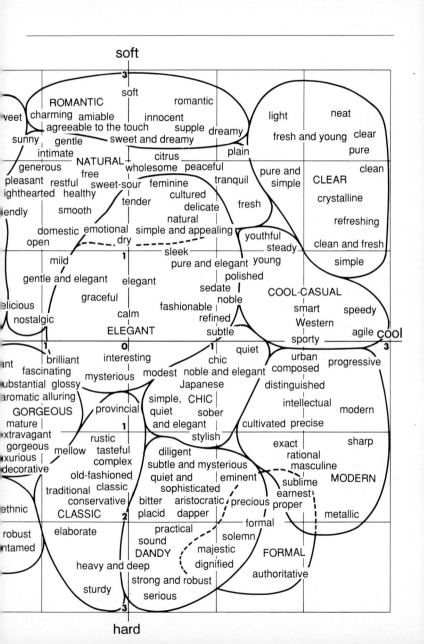

180 Image Word Data Base

Notes

1 The 180 words appear in alphabetical order.
2 These words are referred to in the Key Word Image Scale on pp. 12–13.
3 Among the 180 words, those that are liked/disliked (according to the results of a survey conducted between 1987 and 1988).

Words with a high selection rate as a liked image (ranked in the top thirty words) are marked ●
Words with a low selection rate as a liked image (ranked in the bottom thirty words) are marked △

A

1. abundant △
2. active
3. agile
4. agreeable to the touch
5. alluring
6. amiable
7. amusing △
8. aqueous △
9. aristocratic
10. aromatic
11. authoritative △

B

12. bitter △
13. bold
14. bright △
15. brilliant

C

16. calm
17. casual
18. charming
19. cheerful ●
20. chic ●
21. childlike
22. citrus △
23. classic
24. clean ●
25. clean and fresh △
26. clear
27. colorful
28. complex △
29. composed
30. conservative △
31. crystalline
32. cultivated
33. cultured
34. cute △

D

35. dapper
36. dazzling
37. decorative △
38. delicate
39. delicious
40. dewy △
41. dignified
42. diligent
43. distinguished △
44. domestic ●
45. dreamy
46. dry △
47. dynamic
48. dynamic and active

E

49. earnest
50. elaborate △
51. elegant
52. eminent
53. emotional
54. enjoyable ●

55. ethnic
56. exact
57. extravagant

F

58. fascinating
59. fashionable
60. feminine
61. festive
62. fiery
63. flamboyant
64. forceful
65. formal
66. free ●
67. fresh ●
68. fresh and young
69. friendly ●

G

70. generous ●
71. gentle
72. gentle and elegant
73. glossy
74. gorgeous
75. graceful ●
76. grand ●

H

77. happy
78. healthy ●
79. heavy and deep
80. hot △

I

81. innocent
82. intellectual ●
83. intense
84. interesting

85. intimate
86. intrepid

J

87. Japanese

L

88. light
89. lighthearted
90. lively
91. luxurious

M

92. majestic
93. masculine
94. mature △
95. mellow
96. merry
97. metallic
98. mild
99. modern ●
100. modest
101. mysterious

N

102. natural ●
103. neat
104. noble
105. noble and elegant △
106. nostalgic

O

107. old-fashioned
108. open

P

109. pastoral
110. peaceful ●

111. placid ●
112. plain
113. pleasant
114. polished ●
115. practical
116. precious
117. precise △
118. pretty ●
119. progressive
120. proper △
121. provincial
122. provocative
123. pure
124. pure and elegant
125. pure and simple ●

Q

126. quiet
127. quiet and sophisticated

R

128. rational
129. refined ●
130. refreshing ●
131. restful ●
132. rich
133. robust
134. romantic
135. rustic

S

136. salty △
137. sedate
138. serious
139. sharp ●
140. showy △
141. simple ●

142. simple and appealing ●
143. simple, quiet and elegant △
144. sleek
145. smart
146. smooth
147. sober
148. soft
149. solemn △
150. sound
151. speedy
152. sporty ●
153. steady
154. striking
155. strong and robust △
156. sturdy
157. stylish
158. sublime
159. substantial
160. subtle
161. subtle and mysterious △
162. sunny
163. supple
164. sweet
165. sweet and dreamy △
166. sweet-sour △

T

167. tasteful
168. tender ●
169. traditional
170. tranquil
171. tropical

U

172. untamed
173. urban

	V
174. vigorous	
175. vivid	

	W
176. Western △	

177. wholesome ●
178. wild

	Y
179. young	
180. youthful ●	

Taste and Lifestyle

A simple way to assess your taste

Choose twenty words that correspond to your taste from the Image Word Data Base on pp. 14–17.

Choose ten colors that correspond to your taste from the table on pp. 6–7.

First, consult the Key word Image Scale on pp. 12–13 to check which areas of the scale your chosen words are located in. Then, check the special features of each color you have chosen in the section on that color. Finally, by checking the colors and words you dislike, you can assess the boundaries of your taste.

Thinking about lifestyle

Contemporary life has become colorful, and tastes more varied. From the abundance of objects that surround them people select those which have meaning for them and discard those that do not. So, through the interplay of word and color images in the image scales, we can detect a general pattern in the differences between people's sensitivities. From the differences in individual patterns. We can get a feeling for different kinds of lifestyles. So, in practical terms, when you are creating a new product you can make use of the connections between words, colors, and objects.

Lifestyles have been divided here into eight basic types (see the Key Word Image Scale on pp. 12–13).

Prefers the feeling of clear colors—
Casual: Colorful, enjoys a free and easy lifestyle. Attracted by things with a refreshing, invigorating feel. The related cool-casual lifestyle has recently become more widespread in Japan.
Modern: Cool and sharp. Invigorating.
Romantic (includes pretty): Likes a soft, dream-like atmosphere.
Prefers the calm feeling of grayish colors—
Natural: Likes a light, natural feeling.
Elegant: Calm and delicate.
Chic: Intellectual and refined.
Classic (includes gorgeous): Feeling of tradition, authenticity.
Dandy: Hard and masculine.

The data on each color indicates with which of these eight types of lifestyle that color fits best with. Such basic colors as white, gray, black, or ivory can blend well with any lifestyle.

Eight Taste and Lifestyle Types

Casual

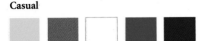

In contrast with formal, casual is cheerful and easygoing. It has an open, wayward, happy image. This type prefers vivid, clear colors, and is mainly attracted by the vivid, strong, or bright tones. Contrasting color combinations using many different hues give a characteristic sporty effect.

Modern

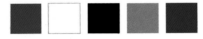

The feeling here is cool and urbane, with a clear-cut, functional, sharp image. Strong contrasts are favored. The neutral colors that we see in fashion, interior design, and of course product design are popular with this type. The key color is black, with white providing a contrast. Vivid colors, giving an accent, are used to create a bold effect. The colors are clear.

Romantic

The colors used here are soft, sweet, and dreamy, with a touch of fantasy. The main color combinations are light pastel tones and white, giving a poetic, soft effect with a feeling of delicacy and sweetness. Since the image is soft and charming, it tends to be popular with young girls. Colors with too strong a hue or too sporty a feel are not suited to this type; the atmosphere is more one of tenderness. The colors used are clear.

Natural

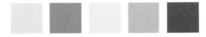

A natural, warm, simple appearance, with a heartwarming image. Full of the richness of natural materials. The feeling here is diametrically opposed to the artificial feeling of modern. The impression is one of serenity. The main colors are shades of beige, ivory, and yellow green. The basic color combinations are subtle gradations of grayish colors.

Elegant

A taste for subtlety, a nonchalant style, beauty with a sense of balance and charm. The elegance one can see in Japanese dress. Refinement, tenderness, and calm—this is the image of elegant. Grayish colors are favored by this type, showy tones and contrasts should be avoided. The color combinations used are subtle gradations.

Chic

This type is sober and calm, quiet and sophisticated, with an air of simple elegance. The atmosphere is quiet and polished, self-possessed, adult, and intelligent, with a cooler image than that of the elegant type. Sober, grayish colors predominate. Color combinations use subtle differences of tones and grayish colors.

Classic

Elaborate, decorative, and formal, an image of authenticity is at the heart of the classic type. The colors used are hard and grayish. The use of brown, black, and olive green gives a feeling of tradition and quality. By adding wine and gold colors a feeling of gorgeousness is created. The contrasts used are moderate, and the feeling is one of calm.

Dandy

A self-possessed tone, stability, masculinity, and quiet sophistication, this is the basis of dandy. Compared to classic, this type is simpler and cooler in feel. The basic colors are hard, such as brown, navy blue, or dark gray, used in combination with calm, grayish colors. This type appeals to a very adult and masculine taste.

	Image	Target Market	Patterns, Materials	Color (p. no.)
Casual	youthful, flamboyant, merry, enjoyable, vivid	young people, university students, or people in their early twenties who aim for a free and easy lifestyle and enjoy life	large checks or stripes; illustrations that look hand drawn; plastic, rubber, cotton	R/V (22) Y/Vp (50) G/V (70) PB/Dk (116) N9.5 (142)
Modern	urban, rational, sharp, progressive, metallic	Young city dwellers with a taste for cool, sharp things; particular about function and design	plain colors are basic; stripes or bold geometrical patterns; steel, glass, stone.	BG/V (82) PB/S (107) N9.5 (142) N6 (146) N1.5 (151)
Romantic	soft, sweet & dreamy, innocent, dreamy, charming	principally young women with a liking for a soft and charming atmosphere; emphasis on softness	soft patterns, e.g., small floral patterns or polka-dot chiffon; delicate lace, white wood, frosted glass	R/Vp (26) BG/Vp (86) PB/Vp (110) RP/Vp (134) N9 (143)
Natural	natural, tranquil, intimate, simple and appealing, generous	people who like a friendly and cheerful feeling and are mentally and physically relaxed; people who aim for comfort in their daily life	plain colors or simple patterns; leaf or tree motifs; linen, cotton, and other natural materials; for living space, wood, bamboo, rattan	YR/L (40) YR/Dl (42) Y/Vp (50) Y/Lgr (51) GY/Lgr (63)
Elegant	refined, graceful, delicate, fashionable, feminine	predominantly women with a sense of gentleness and delicacy; particular about quality and perfume	flowing, curvilinear floral or abstract patterns; glossy materials, such as silk or satin	R/Lgr (27) PB/L (112) P/Gr (125) RP/Lgr (135) N7 (145)
Chic	sober, modest, simple, quiet & elegant, subtle, quiet	people who aim at a calm, cool image; the accent is on an intelligent, polished atmosphere; urbane and adult	sober, subtle, woven patterns; matt finish Buckskin, titanium, natural stone	Y/Gr (53) B/Lgr (99) PB/Gr (113) N8 (144) N5 (147)
Classic	traditional, classic, mature, tasteful, heavy and deep	relatively older people, who aspire to tradition and authenticity; fairly conservative; tend to choose items with ornamentation	traditional, ornamented patterns, such as paisley; lustrous materials, such as gold, silk, and velvet; leather with a heavy deep appearance.	R/Dk (32) YR/Dp (43) YR/Dk (44) GY/Dgr (69) P/Dgr (129)
Dandy	placid, quiet, quiet & sophisticated, sound, dignified, strong & robust	an adult market; fairly masculine; people who like a hard and neat atmosphere	small checks, sober tones, good leather; high-quality materials, such as cashmere and other woolen fabrics	Y/Dl (54) Y/Dgr (57) BG/Dgr (93) B/Dgr (105) N2 (150)

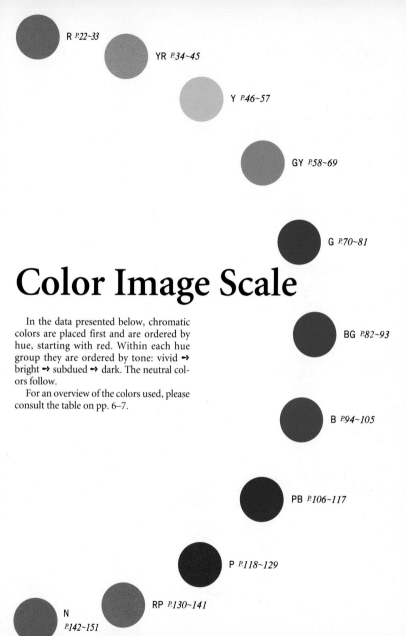

Color Image Scale

R *P.22~33*

YR *P.34~45*

Y *P.46~57*

GY *P.58~69*

G *P.70~81*

BG *P.82~93*

B *P.94~105*

PB *P.106~117*

P *P.118~129*

RP *P.130~141*

N *P.142~151*

In the data presented below, chromatic colors are placed first and are ordered by hue, starting with red. Within each hue group they are ordered by tone: vivid → bright → subdued → dark. The neutral colors follow.

For an overview of the colors used, please consult the table on pp. 6–7.

R

R/V
Carmine

Widely used in...

Fashion	★★★
Interior Design	★
Product Design	★★★★
Visual Media	★★★

Lifestyle...

Casual
Modern

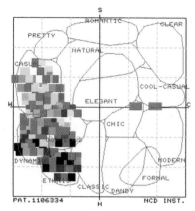

Typical Color Combination Images

festive, bright	★★★★★
forceful, vigorous	★★★★★
hot	★★★★★
bold, lively	★★★★
dynamic and active, dynamic	★★★
intense, sporty	★★★
fiery, wild	★★★
showy, vivid	★★
flamboyant, active	★★
colorful, striking	★★
untamed, provocative	★
fascinating, casual	★

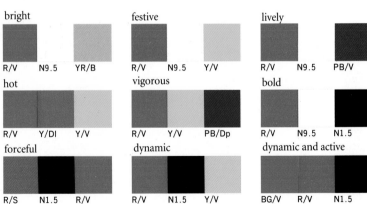

bright
R/V N9.5 YR/B

festive
R/V N9.5 Y/V

lively
R/V N9.5 PB/V

hot
R/V Y/Dl Y/V

vigorous
R/V Y/V PB/Dp

bold
R/V N9.5 N1.5

forceful
R/S N1.5 R/V

dynamic
R/V N1.5 Y/V

dynamic and active
BG/V R/V N1.5

Red can be vermilion or crimson. If vermilion is combined with white or a soft yellow, it conveys a bright, festive, celebratory image. Crimson is widely used in China and Britain, and when combined with black or a hard shade of blue it is vigorous and dynamic, masculine and forceful. If we think of it in terms of taste, it is hot and provocative, with a strong and substantial feeling.

Because red is associated with blood, fire, and the sun, it is also closely connected with festive occasions, curses, and with the pollution traditionally believed by the Japanese to arise from blood, in particular the blood of menstruation and childbirth. This color has a deep connection with life itself.

22

R

R/S
Rouge Coral

Widely used in...		Lifestyle...
Fashion	★★	Casual
Interior Design	★★	Classic
Product Design	★★	
Visual Media	★★	

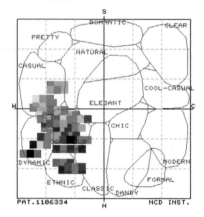

PAT. 1106334

Typical Color Combination Images

abundant	★★★
mature	★★★
rich	★★
alluring	★★
glossy	★★
fascinating	★★
mellow	★

untamed, ethnic, luxurious, dynamic and active, lively, casual

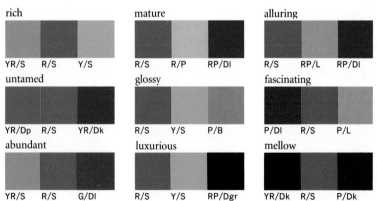

rich
YR/S R/S Y/S

mature
R/S R/P RP/Dl

alluring
R/S RP/L RP/Dl

untamed
YR/Dp R/S YR/Dk

glossy
R/S Y/S P/B

fascinating
P/Dl R/S P/L

abundant
YR/S R/S G/Dl

luxurious
R/S Y/S RP/Dgr

mellow
YR/Dk R/S P/Dk

While vivid tones are clear colors, strong tones are dull. As red becomes duller in tone, it takes on a more material feeling and acquires a ripe, rich image. In packaging this shade conveys maturity and mellowness, in clothes it is alluring and fascinating, and in interiors it gives a sense of luxury.

The combination of rouge coral with dull tones of purple or yellow, rather than with soft colors such as white or ivory, creates a heavy effect but at the same time accentuates this color's wild and gorgeous qualities.

R/B
Rose

Widely used in...

Fashion	★
Interior Design	★
Product Design	
Visual Media	★★★

Lifestyle...

Casual
Romantic

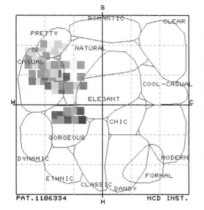

Typical Color Combination Images

cheerful	★★★★★
happy	★★★★
merry	★★★
brilliant	★★
sweet	★
bright	★
colorful	★
festive	★
childlike	★
delicious	★

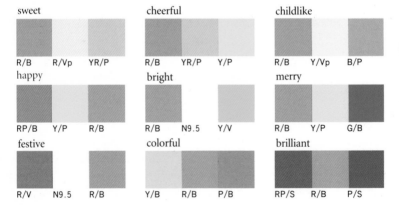

sweet			cheerful			childlike		
R/B	R/Vp	YR/P	R/B	YR/P	Y/P	R/B	Y/Vp	B/P

happy			bright			merry		
RP/B	Y/P	R/B	R/B	N9.5	Y/V	R/B	Y/P	G/B

festive			colorful			brilliant		
R/V	N9.5	R/B	Y/B	R/B	P/B	RP/S	R/B	P/S

This bright tone of red has the image of a ray of hope. It is a luminous, jewel-like tone, a color of joy and good fortune, with the sparkle of a young girl.

Because this is a clear, warm, soft red, it has a childlike quality, sweet and delicious. Combined with yellow or white, it is bright and colorful. Although rose is a color of youth, its charm lies in the fact that it has a wide appeal, not limited to young women alone, as an exciting color, one that draws attention.

R/P
Flamingo

Widely used in...

Fashion	★★
Interior Design	★★
Product Design	
Visual Media	★

Lifestyle...

Romantic

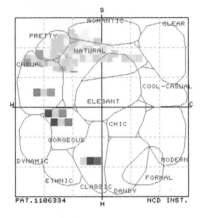

Typical Color Combination Images

sweet	★★★
sweet-sour	★★★
sunny	★★
pretty	★★
sweet and dreamy	★★
generous	★★
cute	★★
feminine	★★
childlike	★★
happy	★★
pleasant	★
smooth, domestic	★

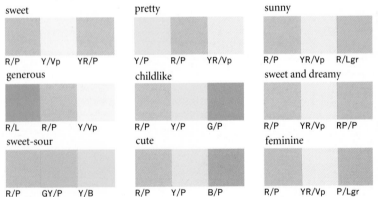

sweet
R/P Y/Vp YR/P

pretty
Y/P R/P YR/Vp

sunny
R/P YR/Vp R/Lgr

generous
R/L R/P Y/Vp

childlike
R/P Y/P G/P

sweet and dreamy
R/P YR/Vp RP/P

sweet-sour
R/P GY/P Y/B

cute
R/P Y/P B/P

feminine
R/P YR/Vp P/Lgr

In Japanese, this color is named after the Japanese crested ibis, or *toki*, which used to be a common sight in Japan. In English, it takes its name from a bird found in southern countries, the flamingo, but it is also known as salmon pink. It has a sweet, dream-like quality; it is a pretty color with a tender feel to it.

Adjectives associated with this color include: romantic, cute, sunny, and generous. It is a color with a soft touch, which appeals to the early teens. Combined with white, yellow, or light blue, it has an image reminiscent of the dreams of children.

R/Vp
Baby Pink

Widely used in...

Fashion	★
Interior Design	
Product Design	★★★
Visual Media	

Lifestyle...

Romantic
Natural
Elegant

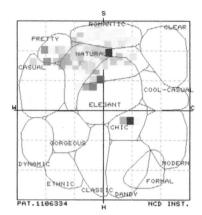

Typical Color Combination Images

sweet and dreamy	★★★
smooth	★★★
supple, innocent	★★
soft, charming	★★
amiable, agreeable to the touch	★★
gentle, cultured	★★
sweet, tender	★
lighthearted, intimate	★
sweet-sour	★

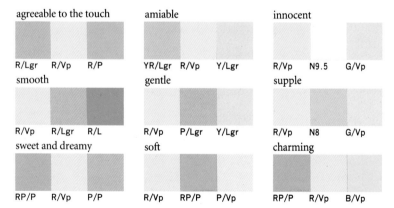

agreeable to the touch

R/Lgr　R/Vp　R/P

amiable

YR/Lgr　R/Vp　Y/Lgr

innocent

R/Vp　N9.5　G/Vp

smooth

R/Vp　R/Lgr　R/L

gentle

R/Vp　P/Lgr　Y/Lgr

supple

R/Vp　N8　G/Vp

sweet and dreamy

RP/P　R/Vp　P/P

soft

R/Vp　RP/P　P/Vp

charming

RP/P　R/Vp　B/Vp

As its name suggests, this is a soft and innocent, clear color. In Japanese, it is called *sakurairo*, or cherry blossom color. Just as the sight of cherry blossoms gladdens the heart, this color creates a sweet and dreamy, supple atmosphere.

Because it is a very pale shade, baby pink gives an impression of tenderness, and is both gentle and cultured. However, that image is lost when it is combined with hard or cool colors.

R/Lgr
Pink Beige

Widely used in...
Fashion
Interior Design ★★
Product Design
Visual Media

Lifestyle...
Elegant
Romantic
Natural

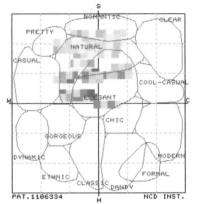

Typical Color Combination Images

smooth·· ★★★
agreeable to the touch······························· ★★★
amiable·· ★★★
tender·· ★★
mild··· ★★
soft··· ★
supple·· ★
gentle and elegant·· ★
cultured·· ★
nostalgic·· ★

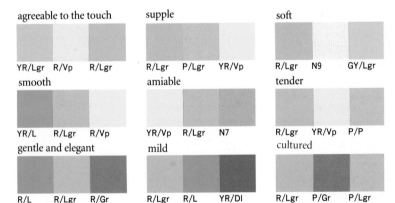

agreeable to the touch
YR/Lgr R/Vp R/Lgr

supple
R/Lgr P/Lgr YR/Vp

soft
R/Lgr N9 GY/Lgr

smooth
YR/L R/Lgr R/Vp

amiable
YR/Vp R/Lgr N7

tender
R/Lgr YR/Vp P/P

gentle and elegant
R/L R/Lgr R/Gr

mild
R/Lgr R/L YR/Dl

cultured
R/Lgr P/Gr P/Lgr

In Japanese, this gentle and elegant color was given the name "cherry blossom haze," because although it has the same flowery feeling as baby pink (in Japanese, cherry blossom pink), it is a hazy, dull color. However, as it becomes more grayish in tone, this pink loses none of its soft, genteel, smooth character.

Pink beige is a color of good taste and refinement, a tender shade, agreeable to the touch. Within Japan, it is particularly popular in the old capital of Kyoto, where the people appreciate it for its delicate quality.

R

R/L
Sandalwood

Widely used in...

Fashion	★★
Interior Design	★★
Product Design	★★
Visual Media	★

Lifestyle...

Elegant
Natural

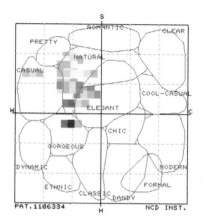

Typical Color Combination Images

pleasant···★★
tender···★★
domestic···★
generous···★
mild···★
casual···★
gentle and elegant···★

emotional, graceful, amiable, lighthearted,
intimate, smooth

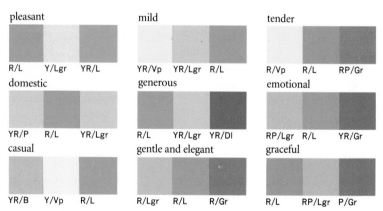

pleasant
R/L Y/Lgr YR/L

mild
YR/Vp YR/Lgr R/L

tender
R/Vp R/L RP/Gr

domestic
YR/P R/L YR/Lgr

generous
R/L YR/Lgr YR/Dl

emotional
RP/Lgr R/L YR/Gr

casual
YR/B Y/Vp R/L

gentle and elegant
R/Lgr R/L R/Gr

graceful
R/L RP/Lgr P/Gr

People take images from nature. In English, this color is named after a tree, while its Japanese name simply means bark color. It is a warm color, domestic and generous in feel, with a tender, pleasant image.

Color combinations using this tone of red are mild, gentle, and elegant. When combined with other shades that are also red in hue, the colors seem to blend naturally into one another, creating an atmosphere of tranquillity. This color also works well for giving accents to an interior.

R

R/Gr
Rose Gray

Widely used in...
Fashion
Interior Design
Product Design
Visual Media

Lifestyle...
Elegant
Chic

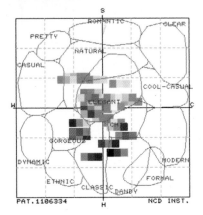

PAT. 1106334

Typical Color Combination Images

calm···★★
gentle and elegant···★★
nostalgic··★★
emotional···★
elegant··★
sleek··★
sedate··★
Japanese···★

mellow, pleasant, practical, chic,
simple, quiet and elegant, provincial

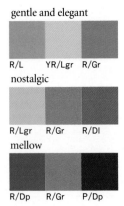

gentle and elegant
R/L YR/Lgr R/Gr

calm
R/Gr N8 GY/Gr

sedate
PB/Vp N7 R/Gr

nostalgic
R/Lgr R/Gr R/Dl

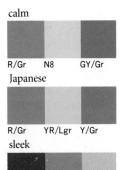

Japanese
R/Gr YR/Lgr Y/Gr

elegant
P/Lgr R/Gr P/Gr

mellow
R/Dp R/Gr P/Dp

sleek
RP/Dl R/Gr RP/Lgr

emotional
R/Gr P/Lgr RP/Gr

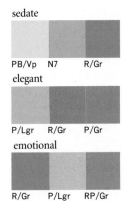

This is a gray color, with a slight tinge of red. It is pleasant and calm, with a warm feel to it. It is difficult to combine rose gray with clear shades, such as white or black. Combined with light grayish or light tones, it is gentle and elegant, while in combination with dull or deep tones, it gives a Japanese effect, pleasant and sedate.

Simple, quiet, elegant colors like these have a quality that is quintessentially Japanese, with a traditional aesthetic of beauty, found in simplicity and restraint, that still lives on in the rooms used for the tea ceremony in Japan. Another example of a color with this quality is mist green (p. 63).

R/Dl
Old Rose

Widely used in...

Fashion ★
Interior Design ★
Product Design
Visual Media ★

Lifestyle...

Classic

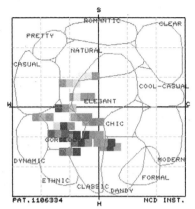

PAT.1106334

NCD INST.

Typical Color Combination Images

mellow ·· ★★
tasteful ··· ★★
nostalgic ··· ★

pleasant, mature, delicious, interesting, alluring, diligent

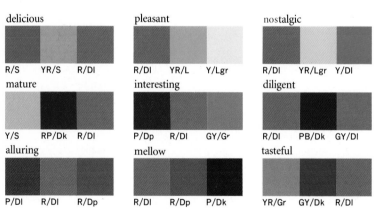

delicious
R/S YR/S R/Dl

pleasant
R/Dl YR/L Y/Lgr

nostalgic
R/Dl YR/Lgr Y/Dl

mature
Y/S RP/Dk R/Dl

interesting
P/Dp R/Dl GY/Gr

diligent
R/Dl PB/Dk GY/Dl

alluring
P/Dl R/Dl R/Dp

mellow
R/Dl R/Dp P/Dk

tasteful
YR/Gr GY/Dk R/Dl

Those who lead a frugal life appreciate the aesthetic of simplicity and restraint. The appeal of this simple but elegant color lies in its quality of restraint and good taste, best appreciated by people who are themselves reserved in character.

When combined with dull tones of red, yellow red, yellow, or green yellow, old rose becomes mellow and mature. In food, it gives a pleasant and delicious impression, when used in knitwear it has an alluring and interesting feel. Its classic image may seem nostalgic to older people.

R

R/Dp
Brick Red

Widely used in...

Fashion	★★
Interior Design	★
Product Design	★★★★
Visual Media	★★

Lifestyle...

Classic

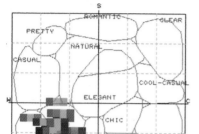

Typical Color Combination Images

robust	★★★★
luxurious	★★★
rich	★★★
untamed, ethnic	★★
extravagant, mellow	★★
dynamic and active, wild	★★
elaborate	★★
mature, substantial	★
decorative, gorgeous	★
hot	★

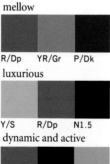

extravagant

R/Dp Y/S P/Dp

mellow

R/Dp YR/Gr P/Dk

ethnic

R/Dp P/Dl Y/Dl

rich

R/Dp Y/S GY/Dk

luxurious

Y/S R/Dp N1.5

elaborate

R/Dp P/Dk BG/Dl

robust

N1.5 R/Dp R/Dk

dynamic and active

R/Dp N1.5 YR/S

untamed

R/Dp N1.5 G/Dk

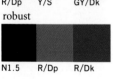

Brick red is the color of burnt earth and has an ethnic, untamed quality. Combining it with a strong yellow accentuates its richness, while with deep tones of purple or green it becomes luxurious, extravagant and elaborate. These warm and hard color combinations are heavy and rustic, with a robust and substantial feel.

This substantial image suggests good quality and northern European and American taste. This is because such color combinations were traditionally favored in countries with long winters.

31

R

R/Dk
Mahogany

Widely used in...

Fashion
Interior Design
Product Design ★★★
Visual Media ★★

Lifestyle..

Classic

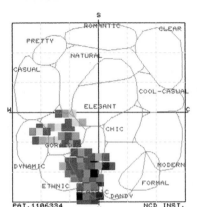

Typical Color Combination Images

traditional ·· ★★★
substantial ··· ★★★
elaborate ··· ★★
old-fashioned ·· ★★
heavy and deep ·· ★
ethnic ··· ★
abundant ·· ★

mellow, mature, rich, untamed, sturdy, strong and robust

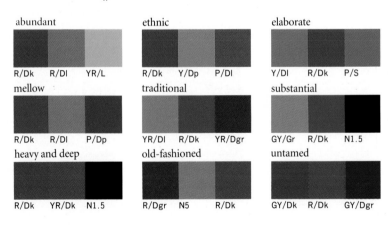

abundant

| R/Dk | R/Dl | YR/L |

ethnic

| R/Dk | Y/Dp | P/Dl |

elaborate

| Y/Dl | R/Dk | P/S |

mellow

| R/Dk | R/Dl | P/Dp |

traditional

| YR/Dl | R/Dk | YR/Dgr |

substantial

| GY/Gr | R/Dk | N1.5 |

heavy and deep

| R/Dk | YR/Dk | N1.5 |

old-fashioned

| R/Dgr | N5 | R/Dk |

untamed

| GY/Dk | R/Dk | GY/Dgr |

Mahogany is a dark tone, heavy and deep with a substantial, traditional image that goes back to the feudal period in Japan, when the color was used by merchants in a way that gave it a feeling of mellowness and maturity. This type of substantial, dark tone conveys an old-fashioned image, with an ethnic touch.

If mahogany is combined with softer shades it is elaborate and mellow, while if combined with a hard shade like black it gives a heavy, deep effect. This color is popular for men's goods.

R/Dgr

Maroon

Widely used in...

Fashion
Interior Design
Product Design
Visual Media

Lifestyle...

Dandy
Classic

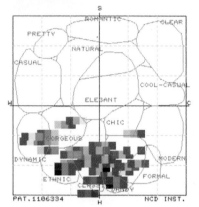

Typical Color Combination Images

placid ·· ★★★
quiet and sophisticated ························· ★★
dignified ·· ★★
serious ·· ★★
wild ··· ★
untamed ·· ★
strong and robust ································· ★
dynamic and active ······························ ★
old-fashioned ······································ ★
robust ··· ★

dynamic and active ✓

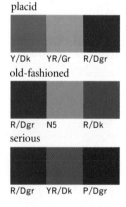

| R/V | Y/V | R/Dgr |

placid

| Y/Dk | YR/Gr | R/Dgr |

quiet and sophisticated

| R/Dgr | Y/Dk | N5 |

wild

| R/V | R/Dgr | Y/S |

old-fashioned

| R/Dgr | N5 | R/Dk |

dignified

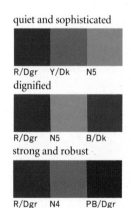

| R/Dgr | N5 | B/Dk |

untamed

| Y/Dp | R/Dp | R/Dgr |

serious

| R/Dgr | YR/Dk | P/Dgr |

strong and robust

| R/Dgr | N4 | PB/Dgr |

Maroon is a very popular color in Europe and the United States. It has a dignified and placid image, essentially masculine. Although it is close to black, it is not as formal, and conveys a serious, robust feeling, deeply rooted in the earth.

The combination of maroon with warm colors, for example, other shades of red, has an untamed feel, while dark tones of yellow bring out its quality of quiet sophistication.

YR

YR/V
Orange

Widely used in...

Fashion
Interior Design
Product Design
Visual Media ★★★

Lifestyle...

Casual

Typical Color Combination Images

dazzling	★★★
enjoyable	★★
casual	★★
abundant	★★
flamboyant	★★
delicious	★★
forceful	★★
lively	★
tropical	★
fiery	★
active	★

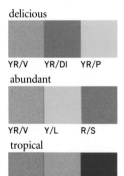

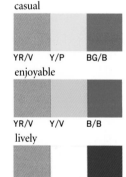

dazzling

R/V YR/V Y/B

delicious

YR/V YR/DI YR/P

casual

YR/V Y/P BG/B

flamboyant

YR/V RP/V Y/V

abundant

YR/V Y/L R/S

enjoyable

YR/V Y/V B/B

forceful

R/V YR/V N1.5

tropical

RP/V YR/V G/Dp

lively

YR/V N9.5 PB/V

Orange is the color of fruit—a delicious color. It is widely used in restaurants and for food. Enjoyable, flamboyant, and lively, orange works well in sporting and leisure facilities, for example, amusement parks.

Combined with soft colors like white or yellow, it creates a casual effect, while with black or red it is forceful and energetic, a dazzling color.

Yellow-red is a basic hue of the necessities of life: food, clothing, and shelter. Skin, wood, and bread also belong to this color group.

YR/S
Persimmon

Widely used in...

Fashion
Interior Design ★
Product Design
Visual Media ★★

Lifestyle...

Casual

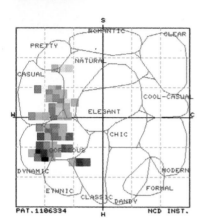

Typical Color Combination Images

rich···★★
delicious··★★
abundant··★★
dynamic and active····························★
aromatic···★

luxurious, bright, fascinating, untamed, enjoyable, substantial

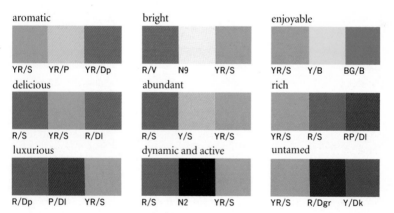

aromatic
YR/S YR/P YR/Dp

bright
R/V N9 YR/S

enjoyable
YR/S Y/B BG/B

delicious
R/S YR/S R/Dl

abundant
R/S Y/S YR/S

rich
YR/S R/S RP/Dl

luxurious
R/Dp P/Dl YR/S

dynamic and active
R/S N2 YR/S

untamed
YR/S R/Dgr Y/Dk

Persimmon is a ripe, delicious color, tasteful and aromatic. When combined with other dull tones of yellow or red, it gives an abundant, rich feeling.

With black or dark tones of red, it creates a luxurious, substantial image, although it can also give a hard effect, dynamic and active, untamed.

This color used to be common in rural Japan, where its warmth was a welcome foil to the cold of winter.

YR

YR/B
Apricot

Widely used in...

Fashion
Interior Design
Product Design
Visual Media ★★

Lifestyle...

Casual

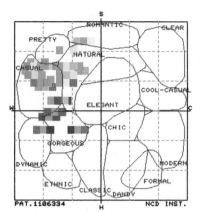

Typical Color Combination Images

friendly···★★
lighthearted···★★
delicious···★★
merry··★★
healthy···★
open···★
amusing··★

bright, tropical, cute, lively, casual, young

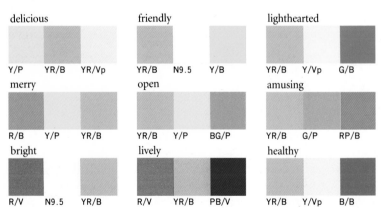

delicious
Y/P YR/B YR/Vp

friendly
YR/B N9.5 Y/B

lighthearted
YR/B Y/Vp G/B

merry
R/B Y/P YR/B

open
YR/B Y/P BG/P

amusing
YR/B G/P RP/B

bright
R/V N9.5 YR/B

lively
R/V YR/B PB/V

healthy
YR/B Y/Vp B/B

Orange, persimmon, and apricot are colors of bounty from heaven, of foods that sustain life. Apricot is a clear color, unlike persimmon, which is dull, and works best in combination with other clear colors. With yellow, it has a lighthearted, open, friendly image, with red or blue, it is lively and young. Used in fashion, this color conveys a casual, free, wayward feeling.

YR/P

Sunset

Widely used in...

Fashion	
Interior Design	★★
Product Design	
Visual Media	★★

Lifestyle...

Natural
Romantic
Casual

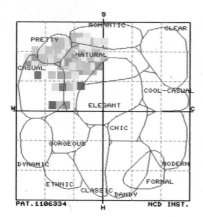

Typical Color Combination Images

lighthearted, friendly	★★★
sunny, free	★★★
cheerful	★★★
domestic, restful	★★
generous, intimate	★★
delicious, sweet	★★
pretty, sweet and dreamy	★
healthy, peaceful	★
childlike, innocent	★
gentle and elegant	★

sweet

R/P YR/Vp YR/P

cheerful

R/B YR/P Y/P

domestic

YR/P R/L YR/Lgr

restful

YR/P Y/Vp GY/Lgr

lighthearted

YR/P Y/Vp Y/L

intimate

YR/Vp YR/P YR/L

sunny

YR/P YR/Vp GY/P

free

YR/P Y/Vp BG/P

friendly

YR/P Y/Vp GY/B

Sunset is a clear, bright, soft tone, friendly and free. As it has a domestic, familiar feel, it works well in the packaging of everyday goods.

When combined with very pale or bright tones, this color conveys a sunny, cheerful, lighthearted image, appropriate to products aimed at children, particularly infants. It should be used with soft colors, as it loses its sweet, sunny quality with hard colors.

YR/Vp
Pale Ochre

Widely used in...
Fashion
Interior Design ★★
Product Design
Visual Media

Lifestyle...
Natural
Romantic
Elegant

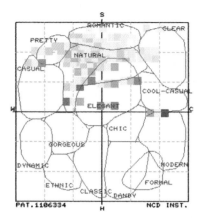

Typical Color Combination Images

intimate, charming···························· ★★★
sunny··· ★★★
soft, delicate······································ ★★
mild, domestic···································· ★★
dreamy, sweet···································· ★★
feminine, amiable································ ★★
supple, sweet and dreamy··················· ★★
tranquil, restful································· ★★
light, smooth····································· ★★
agreeable to the touch························ ★★
pleasant, wholesome···························· ★
innocent, pure and simple, peaceful······· ★

soft

| R/P | N9.5 | YR/Vp |

domestic

| R/P | YR/Vp | GY/Lgr |

dreamy

| YR/Vp | BG/Vp | P/Vp |

intimate

| YR/Vp | YR/L | Y/Lgr |

sunny

| YR/P | YR/Vp | GY/P |

delicate

| RP/Lgr | YR/Vp | N8 |

mild

| YR/Vp | YR/Lgr | R/L |

charming

| RP/P | YR/Vp | B/Vp |

feminine

| RP/Lgr | YR/Vp | P/P |

Pale ochre has a soft, intimate feel and has long been a basic color of everyday life, clothes, and interiors. It can be combined with a wide range of other soft tones, both warm and cold. This color is essential in creating either a romantic and dreamy or a mild and feminine image.

Its sweet, charming quality can also be used to convey a tender and domestic atmosphere. Delicate and soft, pale ochre is a color of nature and of life.

YR/Lgr
French Beige

Widely used in...

Fashion	★★★
Interior Design	★★★
Product Design	★★★
Visual Media	★

Lifestyle...

Natural
Romantic
Elegant

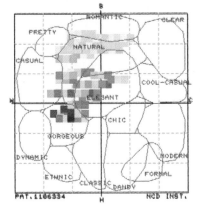

Typical Color Combination Images

gentle	★★★
agreeable to the touch	★★★
pleasant, intimate	★★
generous, mild	★★
dry, amiable	★★
smooth, wholesome	★★
nostalgic	★★
calm, domestic	★
simple and appealing, restful	★
Japanese, gentle and elegant	★
aromatic, grand	★

agreeable to the touch

YR/Lgr	Y/Lgr	Y/Vp

smooth

N9	YR/Lgr	YR/L

generous

YR/Lgr	R/L	YR/Dl

amiable

YR/Lgr	N9.5	Y/Lgr

intimate

YR/Lgr	YR/Vp	Y/Lgr

pleasant

YR/Vp	YR/Lgr	R/Gr

gentle

YR/Lgr	N9	B/Vp

dry

YR/Lgr	YR/Vp	N8

mild

YR/Lgr	YR/Vp	RP/Lgr

In contrast with pale ochre, which is a clear color, French beige is misty and dull. In character it is simple and wholesome, mild and agreeable to the touch, and creates a feeling of intimacy. For this reason, it is one of the basic colors of everyday life and has a wide variety of applications, including products for the home and interior design. Its generous, wholesome quality can be accentuated by combining it with grayish tones, such as rose beige.

YR

YR/L
Beige

Widely used in...		Lifestyle...
Fashion	★★	Natural
Interior Design	★★	Elegant
Product Design		
Visual Media	★★	

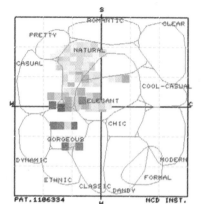

Typical Color Combination Images

intimate··· ★★★
natural, pleasant······································· ★★
calm, domestic··· ★★
generous, gentle and elegant····················· ★★
amiable, wholesome··································· ★★
smooth, aromatic······································· ★★
peaceful, restful·· ★
mild, agreeable to the touch······················ ★
nostalgic··· ★

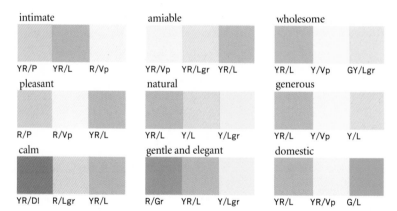

intimate			amiable			wholesome		
YR/P	YR/L	R/Vp	YR/Vp	YR/Lgr	YR/L	YR/L	Y/Vp	GY/Lgr

pleasant			natural			generous		
R/P	R/Vp	YR/L	YR/L	Y/L	Y/Lgr	YR/L	Y/Vp	Y/L

calm			gentle and elegant			domestic		
YR/Dl	R/Lgr	YR/L	R/Gr	YR/L	Y/Lgr	YR/L	YR/Vp	G/L

The best way to bring out the pleasant, calm, comfortable beauty of this shade is to combine it with other tones of a similar hue. With soft tones of yellow or yellowish green it conveys a generous, natural, wholesome feeling. It is also easy to make natural-looking color combinations by using it with hard tones.

Beige creates a feeling of intimacy, and it is one of the basic colors of interiors and is also widely used in clothing.

YR/Gr
Rose Beige

Widely used in...

Fashion	★★★
Interior Design	★★★
Product Design	★★
Visual Media	★★

Lifestyle...

Chic
Elegant
Dandy
Classic

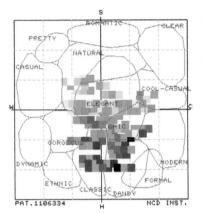

PAT. 1106334

Typical Color Combination Images

placid	★★★
chic, modest	★★
provincial, simple, quiet and elegant	★★
aqueous	★★
subtle and mysterious, calm	★
gentle and elegant, mild	★
tasteful, classic	★
sober, dry	★
diligent, precious	★

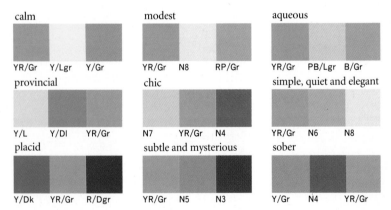

calm
YR/Gr Y/Lgr Y/Gr

modest
YR/Gr N8 RP/Gr

aqueous
YR/Gr PB/Lgr B/Gr

provincial
Y/L Y/Dl YR/Gr

chic
N7 YR/Gr N4

simple, quiet and elegant
YR/Gr N6 N8

placid
Y/Dk YR/Gr R/Dgr

subtle and mysterious
YR/Gr N5 N3

sober
Y/Gr N4 YR/Gr

Grayish tones have a modest feel. These sober and provincial shades have a subtle and mysterious beauty and, for Japanese people, evoke the image of sophistication.

Rose beige is popular for young people's clothing. It is a color with a special appeal for the Japanese, as it is chic and serene, reminiscent of the Japanese countryside in winter.

YR/Dl
Camel

Widely used in...

Fashion	★★
Interior Design	★★★
Product Design	
Visual Media	★★

Lifestyle...

Classic
Natural
Dandy

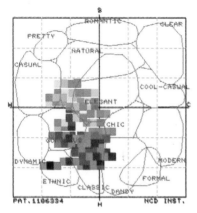

Typical Color Combination Images

aromatic	★★★
classic	★★
old-fashioned	★★
provincial	★★
rustic	★★
diligent	★★
traditional, tasteful	★
calm, simple, quiet and elegant	★
generous, pastoral	★
delicious, robust	★
nostalgic	★

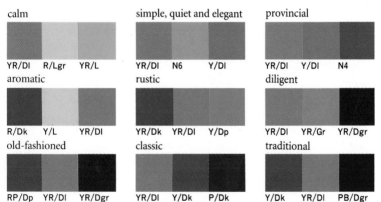

calm
YR/Dl R/Lgr YR/L

simple, quiet and elegant
YR/Dl N6 Y/Dl

provincial
YR/Dl Y/Dl N4

aromatic
R/Dk Y/L YR/Dl

rustic
YR/Dk YR/Dl Y/Dp

diligent
YR/Dl YR/Gr YR/Dgr

old-fashioned
RP/Dp YR/Dl YR/Dgr

classic
YR/Dl Y/Dk P/Dk

traditional
Y/Dk YR/Dl PB/Dgr

In the late nineteenth century, when Japan was opened to the West, this color was a symbol of civilization and enlightenment. Originally it was a rustic and provincial color, but if skillfully used—for example, in vests—it gives a handsome, dashing effect. Used in good quality leather or woollens, it has a fashionable, exclusive feel, while in combination with hard shades, it is traditional and old-fashioned.

YR/Dp
Brown

Widely used in...

Fashion
Interior Design ★
Product Design
Visual Media ★★

Lifestyle...

Classic
Natural
Dandy

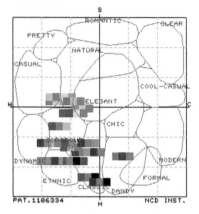

Typical Color Combination Images

aromatic·······································★★★
rustic···★★
practical···★★
grand··★★
sturdy···★★
delicious··★

traditional, nostalgic, pastoral, untamed, wild

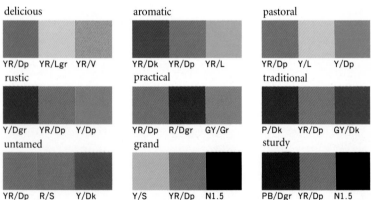

delicious
YR/Dp YR/Lgr YR/V

aromatic
YR/Dk YR/Dp YR/L

pastoral
YR/Dp Y/L Y/Dp

rustic
Y/Dgr YR/Dp Y/Dp

practical
YR/Dp R/Dgr GY/Gr

traditional
P/Dk YR/Dp GY/Dk

untamed
YR/Dp R/S Y/Dk

grand
Y/S YR/Dp N1.5

sturdy
PB/Dgr YR/Dp N1.5

In the feudal period this shade of brown was a smart color, used in *kabuki* and *ukiyoe*, but after Japan was opened to the West it was brought into general use for everyday goods, along with the related shades of beige and camel. Brown became popular at this time, both because it suits the Japanese complexion and because it echoes the colors of nature.

Nowadays, brown has a practical, rustic image, although it can give a fashionable, dandyish effect in combination with black or dark blue.

YR/Dk
Coffee Brown

Widely used in...

Fashion
Interior Design ★★
Product Design
Visual Media

Lifestyle...

Classic
Dandy

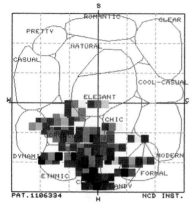

PAT.1106334 NCD INST.

Typical Color Combination Images

rustic ·· ★★★★
practical, conservative ························· ★★★
heavy and deep, placid ························ ★★★
aromatic ·· ★★★
sturdy, substantial ····························· ★★
pastoral, serious ································· ★★
sound, robust ····································· ★★
diligent, old-fashioned ······················ ★★
traditional, quiet and sophisticated ········· ★
mellow, tasteful ································· ★
dapper, bitter ···································· ★

pastoral

| YR/L | Y/Dl | YR/Dk |

aromatic

| YR/Dl | YR/Lgr | YR/Dk |

placid

| YR/Gr | N5 | YR/Dk |

rustic

| Y/S | YR/Dp | YR/Dk |

practical

| YR/Dk | YR/Dl | Y/Dk |

conservative

| YR/Dk | Y/Gr | G/Dgr |

substantial

| R/Dk | Y/S | YR/Dk |

sturdy

| YR/Dk | YR/Dp | N1.5 |

heavy and deep

| PB/Dgr | YR/Dk | N2 |

Coffee brown is a familiar color. Aromatic, substantial, and placid, it can also easily be used to convey a sturdy, practical image. Combining it with black or other shades of brown accentuates its serious character.

These dark tones are popular with men and work well in suits and woollens. With the English shade, camel, its image becomes dandy, quiet and sophisticated, while retaining a placid feel.

YR

YR/Dgr
Falcon

Widely used in...
Fashion
Interior Design
Product Design ★
Visual Media

Lifestyle...
Classic
Dandy

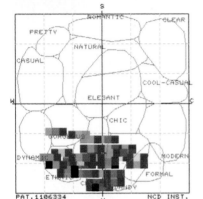

PAT. 1106334 NCD INST.

Typical Color Combination Images

traditional	★★
strong and robust	★★
heavy and deep	★★
sound	★★
quiet and sophisticated	★
tasteful	★
untamed, wild	★
practical, sturdy	★
classic, dapper	★
conservative, diligent	★

traditional

YR/Dgr R/Dk YR/Dl

practical

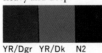

R/Gr YR/Dk YR/Dgr

sound

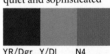

YR/Dgr Y/Gr GY/Dk

sturdy

YR/Dgr YR/Dl Y/Dk

conservative

YR/Dgr YR/Gr Y/Dgr

quiet and sophisticated

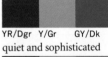

YR/Dgr Y/Dl N4

untamed

YR/Dgr R/V N1.5

heavy and deep

YR/Dgr YR/Dk N2

strong and robust

YR/Dgr N4 N1.5

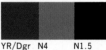

This shade is very close to black and could also be called brownish black. Heavy and deep, with a feeling of soundness and tradition, it is reminiscent of feudal Japan, strong, robust, and untamed. In the frivolous age in which we live,

the retro boom has led people to take a fresh look at this color's quiet sophistication.

Red and black bring out its strong and robust character, while with cool colors, it conveys a heavy, deep, conservative image.

Y/V
Yellow

Widely used in...

Fashion
Interior Design
Product Design ★
Visual Media ★★

Lifestyle...

Casual

Typical Color Combination Images

flamboyant, vivid ···································· ★★★★
dazzling ··· ★★★★
showy, dynamic ·································· ★★★
bold, intense ······································· ★★★
lively, sporty ······································· ★★★
fiery ·· ★★★
dynamic and active, vigorous ·········· ★★
striking, forceful ································· ★★
enjoyable, merry ································· ★★
colorful, tropical ································· ★★
provocative, amusing ························· ★★
citrus, hot ··· ★★

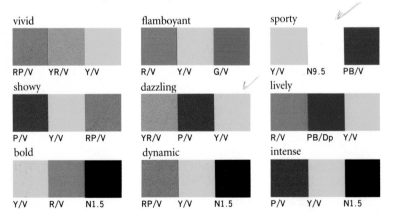

vivid
RP/V YR/V Y/V

flamboyant
R/V Y/V G/V

sporty
Y/V N9.5 PB/V

showy
P/V Y/V RP/V

dazzling
YR/V P/V Y/V

lively
R/V PB/Dp Y/V

bold
Y/V R/V N1.5

dynamic
RP/V Y/V N1.5

intense
P/V Y/V N1.5

Colors of a yellow hue have a completely different image depending on whether they are clear or dull in tone. Although the clear yellow shown here has a cheap image, it is lighthearted and friendly, and, in combination with other hues, creates a flamboyant, vivid, showy, intense effect.

This shade can be either cool or warm. Cool lemon yellow is popular with young people, while warm banana yellow is sporty and ornate.

Y/S
Gold

Widely used in...

Fashion	★
Interior Design	★
Product Design	★★★
Visual Media	★★

Lifestyle...

Classic
Casual

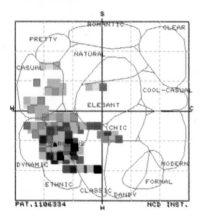

Typical Color Combination Images

luxurious, hot	★★★★★
rich	★★★★
mature, gorgeous	★★★
extravagant, substantial	★★★
decorative, ethnic	★★
glossy	★★
untamed, wild	★
elaborate, intrepid	★
rustic, pastoral	★
salty	★

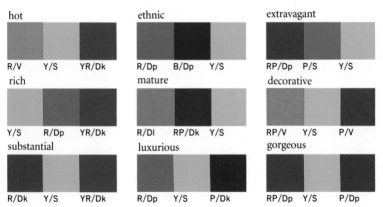

hot
R/V Y/S YR/Dk

ethnic
R/Dp B/Dp Y/S

extravagant
RP/Dp P/S Y/S

rich
Y/S R/Dp YR/Dk

mature
R/Dl RP/Dk Y/S

decorative
RP/V Y/S P/V

substantial
R/Dk Y/S YR/Dk

luxurious
R/Dp Y/S P/Dk

gorgeous
RP/Dp Y/S P/Dp

The Japanese name for this color evokes ripening rice, while its English name, gold, has a mature and luxurious image, full of the richness of nature. Used with vermilion, it has a luxurious and substantial appearance that used to be popular with the merchants of Osaka.

Gold has a dual character: on the one hand it can be extravagant, glossy, and decorative, and is indispensable at the New Year and other Japanese festivals—but it also has a natural side, both simple and appealing.

47

Y

Y/B
Canary Yellow

Widely used in...

Fashion ★★
Interior Design ★
Product Design ★★★
Visual Media ★★★

Lifestyle...

Casual

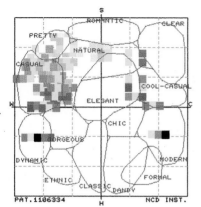

Typical Color Combination Images

casual·· ★★★
youthful, young··· ★★
cheerful, pretty·· ★★
friendly, enjoyable······································ ★★
bold, showy·· ★
open, childlike·· ★
happy, dazzling··· ★
sweet-sour, citrus······································· ★
vivid·· ★

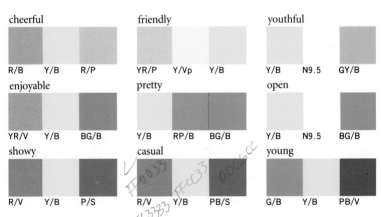

cheerful
R/B Y/B R/P

friendly
YR/P Y/Vp Y/B

youthful
Y/B N9.5 GY/B

enjoyable
YR/V Y/B BG/B

pretty
Y/B RP/B BG/B

open
Y/B N9.5 BG/B

showy
R/V Y/B P/S

casual
R/V Y/B PB/S

young
G/B Y/B PB/V

Of the clear yellows, this bright tone is particularly youthful and pretty. Not as intense or dazzling as a vivid yellow, it is a cheerful, enjoyable color. Bright and soft, in combination with warm colors or clear tones of cool colors, it creates a friendly, open feeling. Red and orange bring out its enjoyable quality, while blue or green accentuate its youthfulness.

In Japanese this shade is called egg-color and is associated with such soft-tasting foods as eggs and cream.

Y/P
Sulphur

Widely used in...

Fashion	★★★
Interior Design	★
Product Design	★
Visual Media	★★

Lifestyle...

Casual
Romantic
Natural

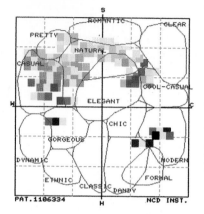

Typical Color Combination Images

cute, childlike	★★★★
citrus	★★★★
young, cheerful	★★★
merry	★★★
youthful, open	★★
healthy, free	★★
lighthearted, happy	★★
active, casual	★★
pretty, sweet-sour	★★
enjoyable, sunny	★

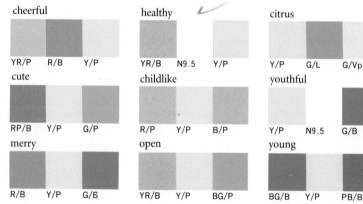

cheerful
YR/P R/B Y/P

healthy
YR/B N9.5 Y/P

citrus
Y/P G/L G/Vp

cute
RP/B Y/P G/P

childlike
R/P Y/P B/P

youthful
Y/P N9.5 G/B

merry
R/B Y/P G/B

open
YR/B Y/P BG/P

young
BG/B Y/P PB/B

As its tone changes from vivid to bright to pale, yellow loses its fiery, dazzling, showy, quality and becomes prettier and more youthful, creating a childlike image. Also, because in Japan this shade is associated with lemon, it has a citrus-like image that might be best conveyed by renaming it lemon yellow.

Combined with warm shades, sulphur has a healthy and open feel, while with cool shades it has a youthful image. It is a soft, friendly color.

Y/Vp
Ivory

Widely used in...

Fashion	★★★★
Interior Design	★★★★
Product Design	★★★★
Visual Media	

Lifestyle...

Natural
Romantic
Casual
Elegant

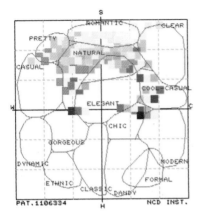

Typical Color Combination Images

wholesome	★★★★
free	★★★
friendly, open	★★
plain, peaceful	★★
dreamy, sweet	★★
gentle, light	★★
generous, healthy	★★
innocent, fresh	★★
cute, pretty	★★
sunny, amiable	★★
agreeable to the touch	★★

gentle

Y/Lgr Y/Vp YR/Lgr

free

YR/P Y/Vp GY/P

wholesome

Y/L Y/Vp GY/Lgr

friendly

YR/P Y/Vp Y/B

dreamy

RP/P Y/Vp B/Vp

plain

Y/Vp GY/Lgr N7

generous

R/L R/P Y/Vp

open

YR/B Y/Vp G/B

peaceful

B/L Y/Vp G/Lgr

Ivory, like beige, is a popular color. Wholesome, free, and friendly in feel, it is a familiar sight in our environment. Light and soft in tone, it can easily be combined with any other color.

Ivory is neither cool, like white, nor warm, like pink. Plain, gentle and generous, this peaceful shade calms the spirit and is well liked in both East and West.

Y

Y/Lgr
Light Olive Gray

Widely used in...

Fashion ★★★
Interior Design ★★★
Product Design ★★★★
Visual Media ★

Lifestyle...

Natural
Elegant

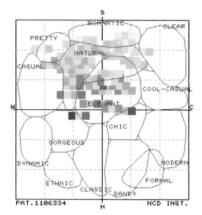

Typical Color Combination Images

tranquil ·· ★★★
intimate ·· ★★★
dry ·· ★★★
restful ·· ★★★
natural, plain ·· ★★
simple and appealing, pleasant ················ ★★
generous, friendly ··································· ★★
gentle and elegant ··································· ★★
calm, peaceful ··· ★
gentle, pastoral ······································· ★
amiable, aromatic ···································· ★
salty ·· ★

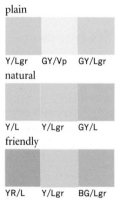

restful

| YR/P | YR/Vp | Y/Lgr |

plain

| Y/Lgr | GY/Vp | GY/Lgr |

tranquil

| Y/Lgr | G/Vp | G/Lgr |

intimate

| YR/L | Y/Lgr | YR/Vp |

natural

| Y/L | Y/Lgr | GY/L |

simple and appealing

| Y/Lgr | GY/L | GY/Gr |

pleasant

| R/L | Y/Lgr | YR/L |

friendly

| YR/L | Y/Lgr | BG/Lgr |

dry

| Y/Lgr | N7 | Y/Gr |

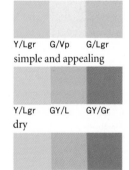

Tranquil, simple and appealing, peaceful and restful—all these words can be used to describe this soft hazy shade with a feeling of stability.

Light olive gray is typical of the natural group of colors. In combination with yellow red or green yellow hues it gives an intimate, restful image. It can be used to lend a human touch to business areas, which tend to have a cool, modern, artificial atmosphere, and in interiors it conveys a friendly effect.

Y

Y/L
Mustard

Widely used in...

Fashion	★★
Interior Design	★
Product Design	★★★
Visual Media	★★

Lifestyle...

Natural

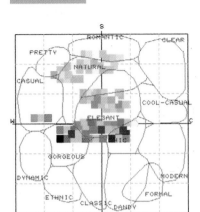

Typical Color Combination Images

natural	★★★
wholesome	★★★
calm	★★
provincial	★★
intimate	★★
simple and appealing	★★
restful	★★
interesting	★
pastoral	★
dry	★
salty	★

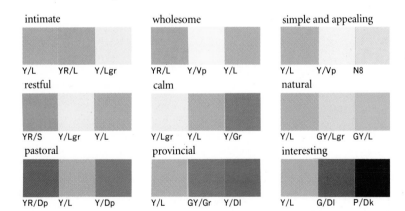

intimate
Y/L YR/L Y/Lgr

wholesome
YR/L Y/Vp Y/L

simple and appealing
Y/L Y/Vp N8

restful
YR/S Y/Lgr Y/L

calm
Y/Lgr Y/L Y/Gr

natural
Y/L GY/Lgr GY/L

pastoral
YR/Dp Y/L Y/Dp

provincial
Y/L GY/Gr Y/Dl

interesting
Y/L G/Dl P/Dk

Mustard, like ivory, is a familiar color. Although it has provocative associations, it is a natural shade, calm and provincial, simple and appealing.

A skillful combination of this color with shades of red or brown adds interest while retaining its intimate quality. With soft colors, it brings out the natural, restful elements in our man-made environment, and can be used to create a pastoral mood within our modern cities.

Y/Gr
Sand Beige

Widely used in...

Fashion	★★
Interior Design	★
Product Design	★
Visual Media	

Lifestyle...

Chic
Dandy
Elegant

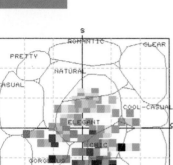

Typical Color Combination Images

conservative, sound	★★★
dry, Japanese	★★★
sober, dapper	★★
nostalgic, subtle and mysterious	★★
calm, simple, quiet and elegant	★★
quiet and sophisticated, provincial	★
practical, simple and appealing	★
modest, authoritative	★
diligent, bitter	★

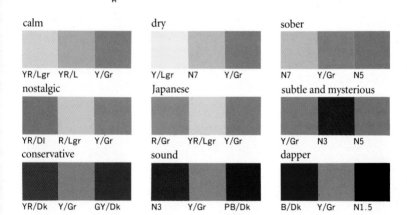

calm — YR/Lgr YR/L Y/Gr
dry — Y/Lgr N7 Y/Gr
sober — N7 Y/Gr N5
nostalgic — YR/Dl R/Lgr Y/Gr
Japanese — R/Gr YR/Lgr Y/Gr
subtle and mysterious — Y/Gr N3 N5
conservative — YR/Dk Y/Gr GY/Dk
sound — N3 Y/Gr PB/Dk
dapper — B/Dk Y/Gr N1.5

The Japanese name for this color, *nibuiro*, conveys a conservative, Japanese image, whereas its English name, sand beige, has a fashionable feel.

This grayish tone no longer has the image of the color yellow. Sober and calm, the simple, quiet and elegant shade is the color of a winter landscape. It goes well with gray and black, creating a subtle and mysterious, but sound, image.

In order to bring out the faint hue of sand beige, it can be combined with both soft and hard tones, accentuating its dapper quality.

Y

Y/Dl
Dusty Olive

Widely used in...

Fashion	★
Interior Design	
Product Design	
Visual Media	★★

Lifestyle...

Dandy
Classic
Chic
Natural

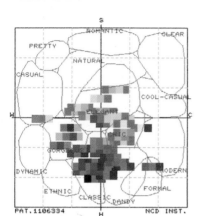

Typical Color Combination Images

provincial	★★★
simple, quiet and elegant	★★★
pastoral	★★
quiet and sophisticated	★★
elaborate	★★
old-fashioned	★★
diligent	★★
nostalgic	★★
mellow, substantial	★
simple and appealing, rustic	★
dapper	★

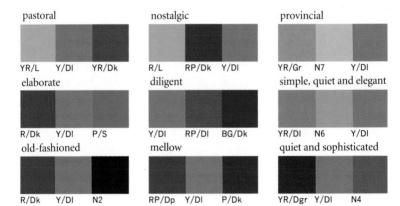

pastoral
YR/L Y/Dl YR/Dk

nostalgic
R/L RP/Dk Y/Dl

provincial
YR/Gr N7 Y/Dl

elaborate
R/Dk Y/Dl P/S

diligent
Y/Dl RP/Dl BG/Dk

simple, quiet and elegant
YR/Dl N6 Y/Dl

old-fashioned
R/Dk Y/Dl N2

mellow
RP/Dp Y/Dl P/Dk

quiet and sophisticated
YR/Dgr Y/Dl N4

Hard tones of yellow seem to have a bluish tinge and are close to green-yellow in hue, hence the English name for this shade, dusty olive. Provincial, pastoral, but with a quiet sophistication, in color combinations it creates a fashionable feel. It has an old-fashioned, simple appeal that is beginning to make it more widely used in interior design.

This color creates a diligent and elaborate mood; it evokes the flavor of a cup of coffee savored in an old café in a street full of new shops.

Y/Dp
Khaki

Widely used in...

Fashion
Interior Design
Product Design
Visual Media ★★

Lifestyle...

Classic
Dandy
Natural

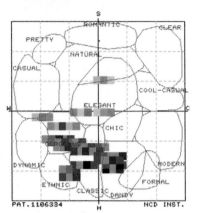

PAT.1106334

NCD INST.

Typical Color Combination Images

bitter·· ★★★★
rustic·· ★★★
gorgeous·· ★★
extravagant·· ★★
elaborate·· ★★
ethnic·· ★
pastoral··· ★
decorative··· ★
wild··· ★
hot·· ★

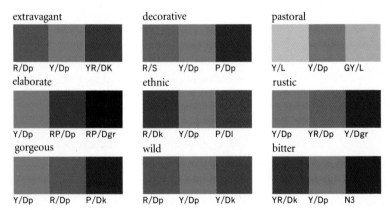

extravagant

R/Dp Y/Dp YR/DK

decorative

R/S Y/Dp P/Dp

pastoral

Y/L Y/Dp GY/L

elaborate

Y/Dp RP/Dp RP/Dgr

ethnic

R/Dk Y/Dp P/Dl

rustic

Y/Dp YR/Dp Y/Dgr

gorgeous

Y/Dp R/Dp P/Dk

wild

R/Dp Y/Dp Y/Dk

bitter

YR/DK Y/Dp N3

The names of colors change with the times. In Japan, the popularity of this shade has led to the loss of its traditional name, which was derived from that of a songbird, and a new name has appeared on the scene: khaki. It is a stern and handsome shade.

Deep tones such as this have a strong, tasteful flavor, and when combined with shades such as red or black convey an elaborate, extravagant impression. However, khaki can also be both ethnic and rustic.

Y

Y/Dk
Olive

Widely used in...

Fashion
Interior Design
Product Design
Visual Media

Lifestyle...

Classic
Dandy

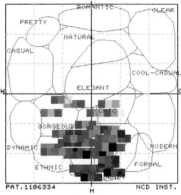

PAT.1106334 NCD INST.

Typical Color Combination Images

bitter ··· ★★★
quiet and sophisticated ·················· ★★
traditional ···································· ★★
placid ·· ★★
sturdy ·· ★★
tasteful ·· ★★
old-fashioned ······························· ★★
untamed, wild ······························· ★
conservative, classic ······················ ★
substantial, diligent ······················ ★

tasteful

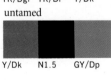

Y/Dk R/Gr P/Dk

placid

Y/Dk Y/Gr N3

bitter

Y/Dk Y/Dp G/Dgr

sturdy

YR/Dgr YR/Dl Y/Dk

quiet and sophisticated

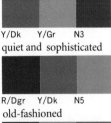

R/Dgr Y/Dk N5

traditional

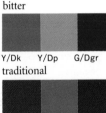

YR/Dgr Y/Dk P/Dk

untamed

Y/Dk N1.5 GY/Dp

old-fashioned

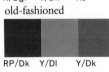

RP/Dk Y/Dl Y/Dk

conservative

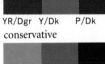

N5 Y/Dk PB/Dgr

Bitter, quiet and sophisticated. A tone of good taste, with only a faint hint of color. Like khaki, olive is subtle, evocative of the beauties of nature, and was a popular shade in premodern Japan. At that time, the colors in everyday use were darker and more restrained than they are today, and to the eye accustomed to such dark shades their quiet elegance must have been apparent.

Even today, people of refined taste can enjoy these tones in the traditional utensils of the tea ceremony.

Y

Y/Dgr
Olive Brown

Widely used in...
Fashion
Interior Design
Product Design
Visual Media

Lifestyle...
Dandy
Classic

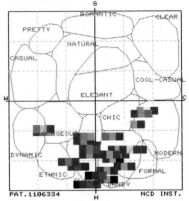

Typical Color Combination Images

rustic···★★
dapper··★★
strong and robust······································★
tasteful···★
serious···★
bitter···★

quiet and sophisticated, heavy and deep,
placid, progressive, rich, sturdy

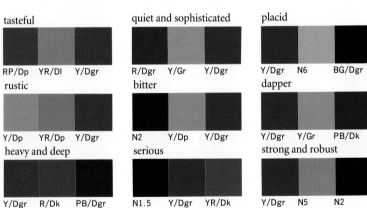

tasteful
RP/Dp YR/Dl Y/Dgr

quiet and sophisticated
R/Dgr Y/Gr Y/Dgr

placid
Y/Dgr N6 BG/Dgr

rustic
Y/Dp YR/Dp Y/Dgr

bitter
N2 Y/Dp Y/Dgr

dapper
Y/Dgr Y/Gr PB/Dk

heavy and deep
Y/Dgr R/Dk PB/Dgr

serious
N1.5 Y/Dgr YR/Dk

strong and robust
Y/Dgr N5 N2

Olive brown is often used for men's suits in Britain. Stylish and dapper, this shade conveys a heavy, deep, placid, and tasteful impression.

Combined with light browns it has a showy image, while with black it has a bitter feel. With gray or blue it is heavy and deep, strong and robust. With this type of dark grayish tone, the hue is easiest to see if it is placed on a black background.

GY

GY/V
Yellow Green

Widely used in...

Fashion
Interior Design
Product Design
Visual Media　　★

Lifestyle...

Casual

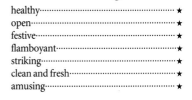

Typical Color Combination Images

healthy···★
open···★
festive···★
flamboyant···★
striking··★
clean and fresh···★
amusing··★

fresh, enjoyable, steady, intense, fiery, tropical

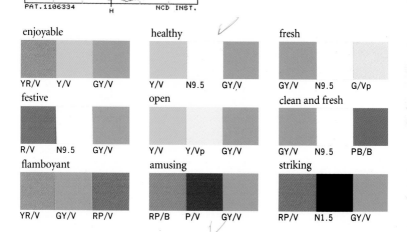

enjoyable

| YR/V | Y/V | GY/V |

healthy

| Y/V | N9.5 | GY/V |

fresh

| GY/V | N9.5 | G/Vp |

festive

| R/V | N9.5 | GY/V |

open

| Y/V | Y/Vp | GY/V |

clean and fresh

| GY/V | N9.5 | PB/B |

flamboyant

| YR/V | GY/V | RP/V |

amusing

| RP/B | P/V | GY/V |

striking

| RP/V | N1.5 | GY/V |

It is perhaps a reflection of the Japanese fondness for new things that the word "green" in Japanese used to refer to yellow green, the color of spring.

Spring is the ultimate symbol of newness, a time when many living things begin to stir and the eye is drawn to the beautiful yellow green of new shoots. It is the freshness of this color that people find appealing.

When combined with red, yellow green is festive, while yellow brings out its healthy, open quality.

GY

GY/S
Grass Green

Widely used in...

Fashion
Interior Design
Product Design ★
Visual Media ★★

Lifestyle...

Natural
Casual

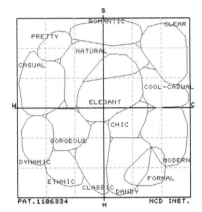

Typical Color Combination Images

Note: Compared to other colors, this shade is infrequently used and so does not appear on the data base. Although we are not used to color combinations incorporating this shade, such combinations do occur in our everyday lives and in nature and can convey many different images. Some examples are given below.

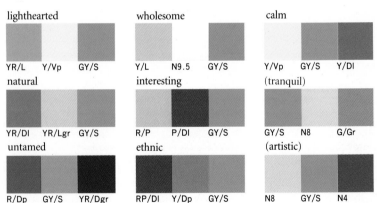

lighthearted
YR/L Y/Vp GY/S

wholesome
Y/L N9.5 GY/S

calm
Y/Vp GY/S Y/Dl

natural
YR/Dl YR/Lgr GY/S

interesting
R/P P/Dl GY/S

(tranquil)
GY/S N8 G/Gr

untamed
R/Dp GY/S YR/Dgr

ethnic
RP/Dl Y/Dp GY/S

(artistic)
N8 GY/S N4

As green yellow loses its bright and vivid quality and becomes more subdued, it also loses its freshness, gaining instead the full bodied feel of green tea.

Grass green is no longer as widely used as it once was. With urbanization, it has lost out to a cooler lifestyle. The combinations above are

therefore offered as an example of how it could be used, in the hope that this shade, with its strong Japanese flavor, may enjoy a revival.

Note: The words in brackets were taken from another data base of 180 words, not shown in this book.

GY/B
Canary

Widely used in...	Lifestyle...
Fashion	Casual
Interior Design	Natural
Product Design	
Visual Media ★★	

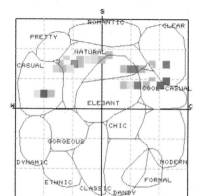

Typical Color Combination Images

fresh··· ★★
youthful·· ★
friendly·· ★

bright, free, steady, cute, sweet-sour, citrus

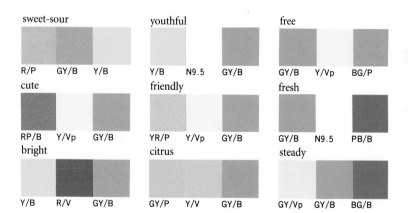

sweet-sour
R/P GY/B Y/B

youthful
Y/B N9.5 GY/B

free
GY/B Y/Vp BG/P

cute
RP/B Y/Vp GY/B

friendly
YR/P Y/Vp GY/B

fresh
GY/B N9.5 PB/B

bright
Y/B R/V GY/B

citrus
GY/P Y/V GY/B

steady
GY/Vp GY/B BG/B

Canary has a tender image. Clear and bright in tone, it has a fresh, youthful feel, evocative of the advent of spring, the breath of life.

This shade of green is widely used in the north of Japan, for example, in Sapporo, Sendai, and Kanazawa, perhaps because of its free, friendly quality. However, there is a trend for the more modern, cooler, blue green shades to be favored over the green yellow group of colors in such large cities as Tokyo.

GY/P
Lettuce Green

Widely used in...
Fashion
Interior Design
Product Design
Visual Media ★★

Lifestyle...
Natural
Casual

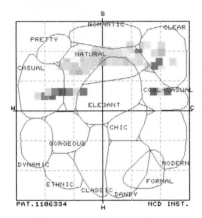

Typical Color Combination Images

free ·· ★★★
sweet-sour ······································· ★★★
citrus ·· ★★
fresh ··· ★★
healthy ·· ★★
youthful ··· ★
tranquil ·· ★
lighthearted ·· ★
fresh and young ··································· ★
amusing ··· ★

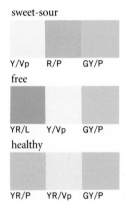

sweet-sour
Y/Vp R/P GY/P

tranquil
GY/P Y/Vp G/Lgr

free
YR/L Y/Vp GY/P

citrus
GY/P Y/V Y/Vp

healthy
YR/P YR/Vp GY/P

lighthearted
YR/B GY/P Y/Vp

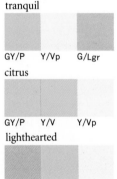

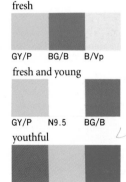

fresh
GY/P BG/B B/Vp

fresh and young
GY/P N9.5 BG/B

youthful
PB/B GY/P B/B

Lettuce green creates a cool, soft atmosphere, free, fresh, and young. Nowadays in Japan, young people often eat salad instead of the traditional miso soup, and this shade evokes that shift in cultural values, echoing the fresh, sweet-sour feel of the collection of modern Japanese haiku entitled *Salad Anniversary*.

Its youthful, fresh quality can be enhanced by combining it with cool shades or white, while using lemon yellow as an accent gives a more lively impression. With orange, the effect is lighthearted and healthy.

GY/Vp
Pale Chartreuse

Widely used in...
Fashion
Interior Design
Product Design ★★★★
Visual Media

Lifestyle...
Natural
Romantic

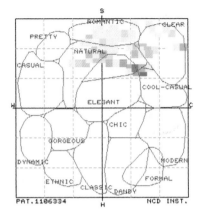

Typical Color Combination Images

sunny··· ★★
tranquil··· ★★
sweet-sour···································· ★★
soft·· ★
plain·· ★
innocent··· ★
steady··· ★
light·· ★

crystalline, fresh, emotional, charming, supple, romantic

innocent

R/Vp	N9.5	GY/Vp

light

Y/Vp	N9.5	GY/Vp

plain

Y/Lgr	GY/Vp	GY/Lgr

sunny

YR/P	YR/Vp	GY/Vp

soft

GY/Vp	R/Vp	PB/Vp

tranquil

GY/Vp	G/Lgr	B/Vp

sweet-sour

GY/Vp	R/P	BG/Vp

emotional

P/Vp	PB/Vp	GY/Vp

steady

GY/Vp	GY/B	BG/B

The Japanese name for this color is taken from the name of a great master of the tea ceremony and conveys a feeling of tranquility redolent of Japanese tradition. Light, clear, and innocent, this shade calms the spirit and gives a sense of steadiness and reliability amid the hustle and bustle of the modern world.

Its dreamy quality can be used to create a romantic mood, while combining it with warm colors brings out its sunny, soft side.

GY/Lgr
Mist Green

Widely used in...

Fashion	★
Interior Design	★★
Product Design	★★★
Visual Media	

Lifestyle...

Natural
Elegant

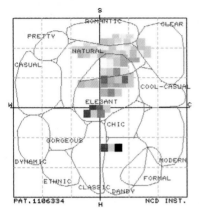

Typical Color Combination Images

plain·· ★★★★
natural··· ★★★
tranquil·· ★★
wholesome·· ★★
pastoral·· ★★
restful·· ★★
soft··· ★
interesting··· ★
domestic··· ★
gentle·· ★

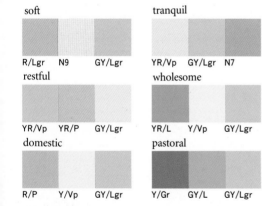
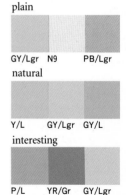

soft
R/Lgr N9 GY/Lgr

tranquil
YR/Vp GY/Lgr N7

plain
GY/Lgr N9 PB/Lgr

restful
YR/Vp YR/P GY/Lgr

wholesome
YR/L Y/Vp GY/Lgr

natural
Y/L GY/Lgr GY/L

domestic
R/P Y/Vp GY/Lgr

pastoral
Y/Gr GY/L GY/Lgr

interesting
P/L YR/Gr GY/Lgr

This delicate shade, like the one preceding, has a traditional Japanese feel, reminiscent of feudal Japan. An old song uses this color to describe falling rain. Neither clear nor dull, bright nor dim, its keynote is subtlety. It echoes the tranquility of nature as perceived in Japan. This shade quiets the spirit and has a restful quality that is lacking in modern life.

GY/L
Pea Green

Widely used in...

Fashion
Interior Design ★
Product Design ★
Visual Media ★★

Lifestyle...

Natural

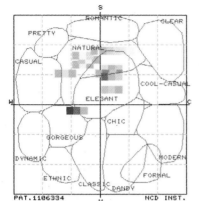

PAT. 1106334 NCD INST.

Typical Color Combination Images

natural·····································★★
domestic··································★
lighthearted····························★
pastoral···································★
wholesome·····························★

peaceful, simple and appealing, generous, restful, mysterious

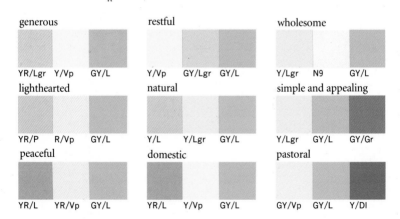

generous
YR/Lgr Y/Vp GY/L

restful
Y/Vp GY/Lgr GY/L

wholesome
Y/Lgr N9 GY/L

lighthearted
YR/P R/Vp GY/L

natural
Y/L Y/Lgr GY/L

simple and appealing
Y/Lgr GY/L GY/Gr

peaceful
YR/L YR/Vp GY/L

domestic
YR/L Y/Vp GY/L

pastoral
GY/Vp GY/L Y/Dl

Light grayish and light tones are now enjoying a revival both inside and outside the home. Perhaps this is a reaction to over-urbanization and the dominance of man-made things in our lives: we seek out colors with a natural feel, for both interiors and exteriors, in order to maintain a balance.

This shade conveys a simple and appealing, generous atmosphere, unsuited to harsh contrasts, that fits in well with a restful landscape and has a strong pastoral feeling.

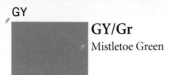

GY/Gr

Mistletoe Green

Widely used in...		Lifestyle...
Fashion	★	Chic
Interior Design	★★	Dandy
Product Design		Classic
Visual Media		

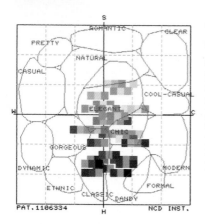

PAT. 1106334 NCD INST.

Typical Color Combination Images

sober··································	★★
provincial·····························	★★
simple and appealing················	★★
modest·································	★★
Japanese······························	★★
traditional·····························	★
practical······························	★
interesting····························	★
pastoral·······························	★

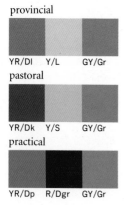

provincial

YR/Dl Y/L GY/Gr

pastoral

YR/Dk Y/S GY/Gr

practical

YR/Dp R/Dgr GY/Gr

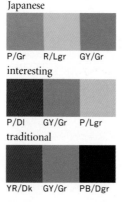

Japanese

P/Gr R/Lgr GY/Gr

interesting

P/Dl GY/Gr P/Lgr

traditional

YR/Dk GY/Gr PB/Dgr

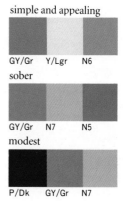

simple and appealing

GY/Gr Y/Lgr N6

sober

GY/Gr N7 N5

modest

P/Dk GY/Gr N7

Sober, provincial shades are popular in Japan, where there is a tendency to avoid showy colors in favor of a more subtle effect. Even young people in Japan find these grayish tones attractive, perhaps because they are drawn to their finesse and subtlety.

This shade produces a retro, Japanesque effect. Its modest quality can be brought out by combining it with gray and purple, while with colors of a warm brown hue it is simple and appealing.

GY

GY/Dl
Leaf Green

Widely used in...

Fashion
Interior Design ★
Product Design
Visual Media ★★

Lifestyle...

Classic
Chic
Dandy

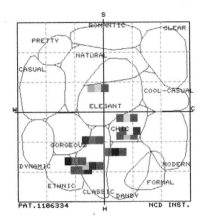

Typical Color Combination Images

Japanese···★
mature, ethnic, diligent,
simple, quiet and elegant,
pastoral, rustic, wild

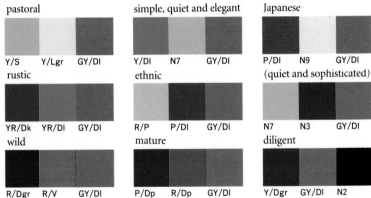

pastoral
Y/S Y/Lgr GY/Dl

simple, quiet and elegant
Y/Dl N7 GY/Dl

Japanese
P/Dl N9 GY/Dl

rustic
YR/Dk YR/Dl GY/Dl

ethnic
R/P P/Dl GY/Dl

(quiet and sophisticated)
N7 N3 GY/Dl

wild
R/Dgr R/V GY/Dl

mature
P/Dp R/Dp GY/Dl

diligent
Y/Dgr GY/Dl N2

There is beauty in dull colors. They are tasteful and give a feeling of maturity and good quality, suggestive of pottery or metalwork. This high-caliber feeling (or feeling of high caliber) is enhanced if this shade is combined with others having only a faint hue, for example, grayish or dull tones. However, leaf green always retains a somewhat rustic, ethnic image, associated with craftwork. In combination with other shades it adds a human touch.

GY/Dp
Olive Green

Widely used in...

Fashion
Interior Design
Product Design ★★
Visual Media

Lifestyle...

Classic

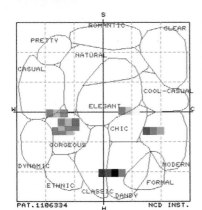

Typical Color Combination Images

untamed··· ★
grand··· ★

heavy and deep, mature, rich, abundant

PAT. 1106334

NCD INST.

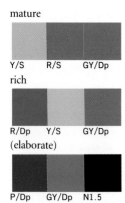

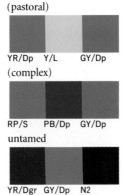

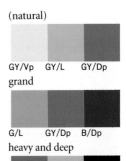

mature
Y/S R/S GY/Dp

rich
R/Dp Y/S GY/Dp

(elaborate)
P/Dp GY/Dp N1.5

(pastoral)
YR/Dp Y/L GY/Dp

(complex)
RP/S PB/Dp GY/Dp

untamed
YR/Dgr GY/Dp N2

(natural)
GY/Vp GY/L GY/Dp

grand
G/L GY/Dp B/Dp

heavy and deep
GY/Dp N7 N1.5

Of the dark shades, deep tones have the highest color saturation and can therefore give quite a showy effect. When making color combinations with this shade, vivid tones should be avoided in order to let the showiness of the deep tone emerge in an unforced way.

Olive green gives a mature, rich, luxurious effect when used with deep tones of red or yel-low, while with black or cool colors it becomes heavy and deep and conveys a more masculine impression.

Note: The color combinations in brackets are not part of the test data and have been in-cluded for reference purposes only. Please use them to develop ideas for color combinations.

GY

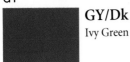

GY/Dk
Ivy Green

Widely used in...

Fashion
Interior Design
Product Design
Visual Media ★

Lifestyle...

Classic
Dandy

Typical Color Combination Images

untamed ·· ★★
wild ··· ★★
conservative ·· ★
ethnic ··· ★
pastoral ··· ★
tasteful ·· ★

subtle and mysterious, quiet and sophisticated, modest, traditional, elaborate, substantial

wild

R/Dk	Y/S	GY/Dk

pastoral

YR/Dl	GY/Lgr	GY/Dk

subtle and mysterious

P/Gr	N4	GY/Dk

ethnic

P/Dk	R/S	GY/Dk

tasteful

R/Dl	GY/Dk	YR/Gr

quiet and sophisticated

GY/Dk	Y/Dl	N3

untamed

YR/Dgr	R/Dp	GY/Dk

traditional

P/Dk	YR/Dp	GY/Dk

conservative

YR/Dk	Y/Gr	GY/Dk

Wild and strong, untamed and hard are the characteristics of ivy green. But it also has another side, hinted at its Japanese name, deep moss—the quiet sophistication of old moss, as in a rock garden.

In combination with red or brown this shade conveys an ethnic effect, while with light brown a calm, pastoral, tasteful mood is created. With black or cool colors it is sophisticated, subtle and mysterious and has a hard, conservative, traditional image. It can also be used to give an elaborate, distinguished feel to food packaging.

GY/Dgr
Seaweed

Widely used in...

Fashion
Interior Design
Product Design
Visual Media

Lifestyle...

Dandy
Classic

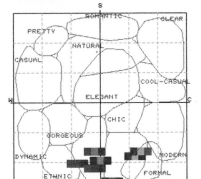

Typical Color Combination Images

solemn, traditional, practical, masculine, serious, untamed, diligent

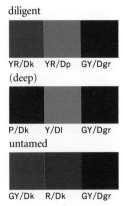

diligent

| YR/Dk | YR/Dp | GY/Dgr |
(deep)

| P/Dk | Y/Dl | GY/Dgr |
untamed

| GY/Dk | R/Dk | GY/Dgr |

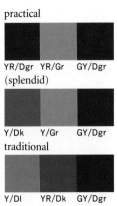

practical

| YR/Dgr | YR/Gr | GY/Dgr |
(splendid)

| Y/Dk | Y/Gr | GY/Dgr |
traditional

| Y/Dl | YR/Dk | GY/Dgr |

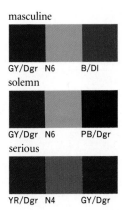

masculine

| GY/Dgr | N6 | B/Dl |
solemn

| GY/Dgr | N6 | PB/Dgr |
serious

| YR/Dgr | N4 | GY/Dgr |

Only a faint tinge of color distinguishes this shade from dark gray. The atmosphere it conveys is solemn and traditional.

In combination with warm shades of a brown hue, it creates a feeling of practicality and diligence, while with gray or cool shades it becomes hard and masculine and gives an impression of steadiness. Try combining it with light shades, which will help to avoid creating too heavy an effect and bring out the beauty of this shade of green yellow.

Note: The words in brackets were taken from another data base of 189 words, not shown in this book.

G/V
Green

Widely used in...
Fashion
Interior Design
Product Design ★
Visual Media ★★

Lifestyle...
Casual
Modern

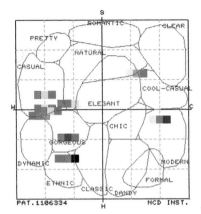

Typical Color Combination Images

flamboyant ···································· ★★
vivid ··· ★★
steady ··· ★

lively, vigorous, showy, provocative, dynamic and active

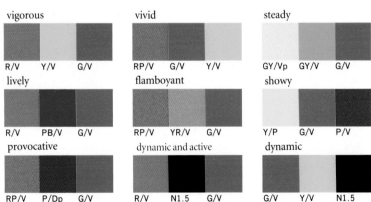

vigorous
R/V Y/V G/V

vivid
RP/V G/V Y/V

steady
GY/Vp GY/V G/V

lively
R/V PB/V G/V

flamboyant
RP/V YR/V G/V

showy
Y/P G/V P/V

provocative
RP/V P/Dp G/V

dynamic and active
R/V N1.5 G/V

dynamic
G/V Y/V N1.5

Green-yellow shades have a Japanese feel, while the blue-green group are Western colors. Yellow-green evokes a rice field, and blue-green a meadow. The green shades in this category fall between the two and do not really appeal to the Japanese.

' The shade of green shown here has a distinctive steady, but lively, image. It is also associated with moisture. For this reason, it is used for the packaging of natural or health foods. When combined with warm colors it gives a flamboyant impression.

G

G/S
Malachite Green

Widely used in...

Fashion	★★
Interior Design	
Product Design	★★
Visual Media	★★

Lifestyle...

Casual

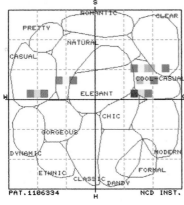

PAT.1106334

NCD INST.

Typical Color Combination Images

steady·· ★

fresh, clean and fresh, young, flamboyant

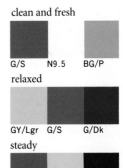

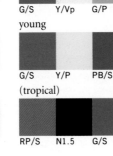

(youthful)

GY/V	Y/P	G/S

fresh

G/S	Y/Vp	G/P

clean and fresh

G/S	N9.5	BG/P

flamboyant

RP/V	Y/V	G/S

young

G/S	Y/P	PB/S

relaxed

GY/Lgr	G/S	G/Dk

(dynamic)

Y/V	G/S	N1.5

(tropical)

RP/S	N1.5	G/S

steady

G/S	N8	PB/Dk

Although colors of a green hue have a strong feeling of mountains and fields, this shade takes its Japanese name from the verdigris of copper rooves, probably because Japanese people associate it with the rooves of shrines where they go to worship.

Malachite green is a dull color, but it has a cool quality that gives an impression of fresh-

ness. When combined with warm colors it creates a flamboyant effect, while with cool colors it has a steady, clean, fresh feeling.

Note: The color combinations in brackets are not part of the test data and have been included for reference purposes only. Please use them as further ideas for color combinations.

71

G

G/B
Emerald

Widely used in...

Fashion
Interior Design
Product Design
Visual Media ★★

Lifestyle...

Casual

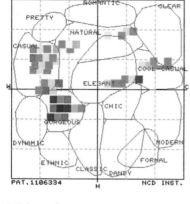

PAT. 1106334

NCD INST.

Typical Color Combination Images

provocative·····································★
merry··★

fresh, youthful, enjoyable, bright, showy, open, lighthearted

lighthearted		
YR/B	Y/Vp	G/B

open		
Y/Vp	Y/B	G/B

fresh		
Y/Vp	GY/P	G/B

enjoyable		
R/B	Y/P	G/B

bright		
R/V	RP/Vp	G/B

youthful		
G/B	N9.5	PB/B

merry		
RP/B	Y/V	G/B

showy		
R/V	Y/V	G/B

provocative		
RP/V	G/B	P/Dp

As society becomes more urbanized we try to compensate for the lack of green in our everyday lives and to restore a balance. In this context, shades with a cool, refreshing feeling have become increasingly popular.

Emerald green, with its merry, open feeling, lifts the spirits and cheers you if you are feeling depressed. Combined with clear shades of red, orange, or yellow, it is youthful, provocative, and enjoyable. With cool colors or with white, it has a refreshing, new feel. Under strong sunlight, this bright green goes well with shades of a yellow or orange hue.

G

G/P
Opaline Green

Widely used in...

Fashion
Interior Design
Product Design
Visual Media ★★

Lifestyle...

Natural
Casual

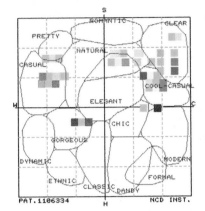

Typical Color Combination Images

steady ··· ★★
refreshing ·· ★
cute ··· ★

pure and simple, fresh, fresh and young, progressive, open, free

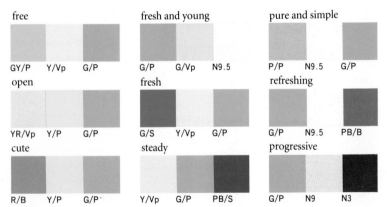

| free | | |
| GY/P | Y/Vp | G/P |

| fresh and young | | |
| G/P | G/Vp | N9.5 |

| pure and simple | | |
| P/P | N9.5 | G/P |

| open | | |
| YR/Vp | Y/P | G/P |

| fresh | | |
| G/S | Y/Vp | G/P |

| refreshing | | |
| G/P | N9.5 | PB/B |

| cute | | |
| R/B | Y/P | G/P· |

| steady | | |
| Y/Vp | G/P | PB/S |

| progressive | | |
| G/P | N9 | N3 |

Combined with warm colors, opaline green is cute, open, free and childlike. With cool colors or with white, it is clean and refreshing and can also give a youthful effect.

The soft, clear qualities of this pale tone can be best appreciated when it is combined with very pale or bright tones, creating a fresh and young feeling. Because it is a clear color, it tends to have a cute, romantic image. It is difficult to create an elegant, chic impression with this shade.

G/Vp
Pale Opal

Widely used in...

Fashion
Interior Design
Product Design ★★★
Visual Media

Lifestyle...

Natural
Romantic
Casual

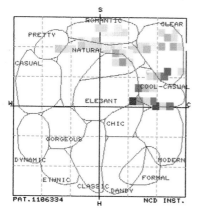

Typical Color Combination Images

innocent·· ★★
clear·· ★
supple··· ★
neat·· ★
fresh and young··· ★
citrus··· ★

fresh, quiet, progressive, charming, delicate, tranquil

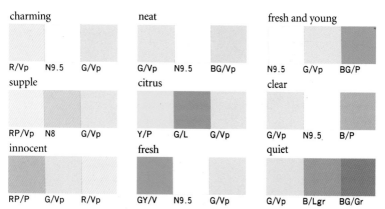

charming

R/Vp N9.5 G/Vp

neat

G/Vp N9.5 BG/Vp

fresh and young

N9.5 G/Vp BG/P

supple

RP/Vp N8 G/Vp

citrus

Y/P G/L G/Vp

clear

G/Vp N9.5 B/P

innocent

RP/P G/Vp R/Vp

fresh

GY/V N9.5 G/Vp

quiet

G/Vp B/Lgr BG/Gr

This is a clear color—crystalline, refreshing, and pure. However, as it is green in hue, it also has a cool quality, and this together with its very pale tone gives it an innocent, supple, neat feeling.

One effective way of bringing out this image is to combine pale opal with cool, soft, colors or with white. Alternatively, it can be combined with warm, soft, shades to create an innocent, supple, charming impression. It is also easy to convey a quiet, fresh feeling with this shade.

G

G/Lgr
Ash Gray

Widely used in...

Fashion	★
Interior Design	★
Product Design	
Visual Media	

Lifestyle...

Natural
Casual
Romantic

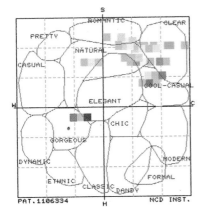

PAT.1106334

Typical Color Combination Images

tranquil·· ★★★
plain··· ★★
peaceful·· ★

crystalline, pure and simple, supple, natural, domestic, simple and appealing

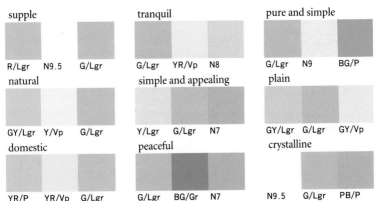

supple
R/Lgr N9.5 G/Lgr

tranquil
G/Lgr YR/Vp N8

pure and simple
G/Lgr N9 BG/P

natural
GY/Lgr Y/Vp G/Lgr

simple and appealing
Y/Lgr G/Lgr N7

plain
GY/Lgr G/Lgr GY/Vp

domestic
YR/P YR/Vp G/Lgr

peaceful
G/Lgr BG/Gr N7

crystalline
N9.5 G/Lgr PB/P

In Japanese we call this color light mist green, as the image of this hazy tone is that of the new green of a wood shrouded in mist, full of the tranquility of nature.

A tablecloth of this shade will give a simple and appealing, pure feel to a dining table. In the urban environment, where green is lacking, it is an effective shade for offices. If the chroma is reduced slightly, it can be used in wrapping to give a fashionable impression with a human touch.

G

G/L
Spray Green

Widely used in...

Fashion
Interior Design ★
Product Design
Visual Media ★★★

Lifestyle...

Natural
Casual

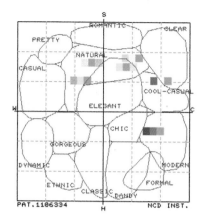

Typical Color Combination Images

fresh, fresh and young, citrus, healthy, peaceful, grand

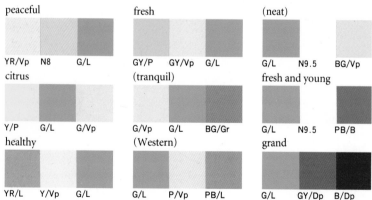

peaceful

YR/Vp	N8	G/L

fresh

GY/P	GY/Vp	G/L

(neat)

G/L	N9.5	BG/Vp

citrus

Y/P	G/L	G/Vp

(tranquil)

G/Vp	G/L	BG/Gr

fresh and young

G/L	N9.5	PB/B

healthy

YR/L	Y/Vp	G/L

(Western)

G/L	P/Vp	PB/L

grand

G/L	GY/Dp	B/Dp

The Japanese name for this color—young bamboo—evokes the image of a recently planted bamboo grove. It has the feeling of young bamboo, fresh, healthy, and gentle.

The cool, noble feeling of white and blue china has always been popular in Japan, as we tend to prefer objects with a light quality to those with a more heavy appearance.

If this shade is combined with white or with cool colors, it has a refreshing effect. With warm colors it has a quiet feel.

Note: The color combinations in brackets are not part of the data and have been included for reference purposes only. Please use them as further ideas for color combinations.

G

G/Gr
Mist Green II

Widely used in...

Fashion
Interior Design ★
Product Design ★
Visual Media

Lifestyle...

Chic

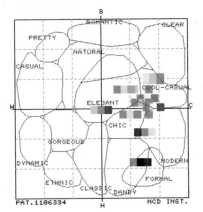

Typical Color Combination Images

quiet ·· ★
grand ·· ★

stylish, urban, fashionable, sober, peaceful, interesting, smart

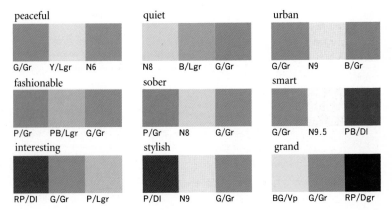

peaceful

G/Gr Y/Lgr N6

fashionable

P/Gr PB/Lgr G/Gr

interesting

RP/Dl G/Gr P/Lgr

quiet

N8 B/Lgr G/Gr

sober

P/Gr N8 G/Gr

stylish

P/Dl N9 G/Gr

urban

G/Gr N9 B/Gr

smart

G/Gr N9.5 PB/Dl

grand

BG/Vp G/Gr RP/Dgr

In shades with a dark tinge, such as this one, the feeling of the original color is weakened, and its delicacy and subtlety are no longer apparent.

However, if you wish to create a tranquil mood, such sober, fashionable, and interesting shades as mist green are very effective. These pleasant grayish tones, with their relaxed beauty, can be used to create a chic and stylish environment with a lasting appeal.

G

G/Dl
Jade Green

Widely used in...

Fashion	★★
Interior Design	
Product Design	
Visual Media	★★

Lifestyle...

Classic

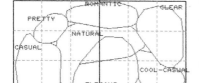

Typical Color Combination Images

complex···★

interesting, abundant

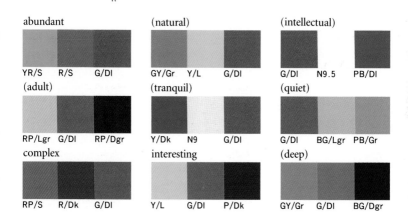

abundant

YR/S	R/S	G/Dl

(adult)

RP/Lgr	G/Dl	RP/Dgr

complex

RP/S	R/Dk	G/Dl

(natural)

GY/Gr	Y/L	G/Dl

(tranquil)

Y/Dk	N9	G/Dl

interesting

Y/L	G/Dl	P/Dk

(intellectual)

G/Dl	N9.5	PB/Dl

(quiet)

G/Dl	BG/Lgr	PB/Gr

(deep)

GY/Gr	G/Dl	BG/Dgr

In Japanese, this color takes its name from a type of rush, a graceful, long, and slender plant, and like the plant it has a quiet elegance that appeals to Japanese sensibilities.

Combined with shades of a purple hue, jade green is interesting and fashionable, while with warm colors it has a more mellow, abundant feel. It also works well in combination with different tones of a similar hue, creating a refined, quiet effect. This is a shade that may enjoy a revival as our culture becomes more mature.

Note: The color combinations in brackets are not part of the data and have been included for reference purposes only. Please use them as further ideas for color combinations.

G/Dp
Viridian

Widely used in...
Fashion
Interior Design
Product Design
Visual Media ★

Lifestyle...
Casual

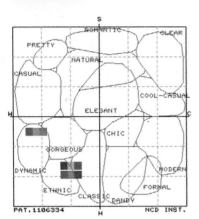

Typical Color Combination Images

ethnic, tropical, wild

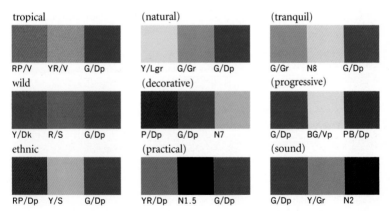

tropical
RP/V YR/V G/Dp

(natural)
Y/Lgr G/Gr G/Dp

(tranquil)
G/Gr N8 G/Dp

wild
Y/Dk R/S G/Dp

(decorative)
P/Dp G/Dp N7

(progressive)
G/Dp BG/Vp PB/Dp

ethnic
RP/Dp Y/S G/Dp

(practical)
YR/Dp N1.5 G/Dp

(sound)
G/Dp Y/Gr N2

This is a heavy shade of green, the color of the depths of the forests and mountains. Cool and hard, it evokes forests or jungles, and is not a commonly seen color.

This shade's quiet, placid, sound qualities can be brought out by combining it with cool colors, such as gray, black, or navy blue, or alternatively with other shades of green. In com-

bination with showy, warm colors it gives an ethnic effect, while with strong, deep tones of a warm hue it has an elaborate, unique feel.

Note: The color combinations in brackets are not part of the data and have been included for reference purposes only. Please use them as further ideas for color combinations.

G

G/Dk
Bottle Green

Widely used in...

Fashion ★
Interior Design
Product Design
Visual Media ★

Lifestyle...

Classic
Dandy

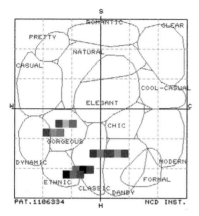

Typical Color Combination Images

untamed, robust, practical, rich, abundant, classic

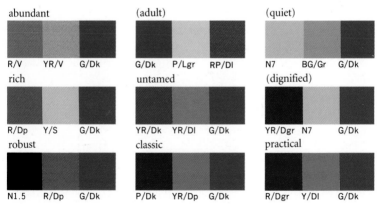

abundant		
R/V	YR/V	G/Dk

(adult)		
G/Dk	P/Lgr	RP/Dl

(quiet)		
N7	BG/Gr	G/Dk

rich		
R/Dp	Y/S	G/Dk

untamed		
YR/Dk	YR/Dl	G/Dk

(dignified)		
YR/Dgr	N7	G/Dk

robust		
N1.5	R/Dp	G/Dk

classic		
P/Dk	YR/Dp	G/Dk

practical		
R/Dgr	Y/Dl	G/Dk

This shade evokes the taiga (a region of coniferous forest) of Siberia. A huge, apparently endless forest covers the frozen earth. Robust, but with a hidden severity, it has a masculine image.

When used with such contrasting colors as red, orange, or yellow, bottle green has an untamed and robust feel. With shades of a brown hue, it creates a classic, practical atmosphere reminiscent of the forests of Germany. This shade also recalls the dashing quality of the clothes worn by samurai in feudal Japan.

Note: The color combinations in brackets are not part of the data and have been included for reference purposes only. Please use them as further ideas for color combinations.

G

G/Dgr
Jungle Green

Widely used in...

Fashion
Interior Design
Product Design
Visual Media

Lifestyle...

Dandy
Classic

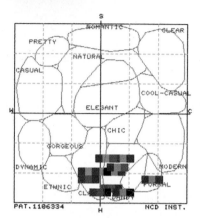

PAT. 1106334 NCD INST.

Typical Color Combination Images

bitter·····································★★
quiet and sophisticated·····················★
heavy and deep·····························★

placid, dignified, sound, strong and robust, conservative

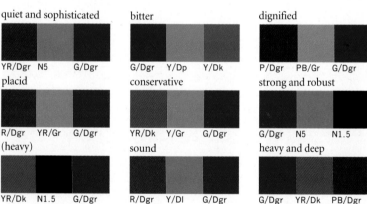

quiet and sophisticated
YR/Dgr N5 G/Dgr

bitter
G/Dgr Y/Dp Y/Dk

dignified
P/Dgr PB/Gr G/Dgr

placid
R/Dgr YR/Gr G/Dgr

conservative
YR/Dk Y/Gr G/Dgr

strong and robust
G/Dgr N5 N1.5

(heavy)
YR/Dk N1.5 G/Dgr

sound
R/Dgr Y/Dl G/Dgr

heavy and deep
G/Dgr YR/Dk PB/Dgr

Seen from a distance, forests have a hazy appearance. As night falls, any faint hint of hue remaining in the forest is lost. Finally, the forest sinks into complete darkness, everything is black. This shade is that of the forest just before it becomes completely dark—heavy and deep, placid, with a quiet sophistication.

Combined with light gray and brown or black, the effect is conservative and dignified. Used in food packaging, this shade gives a feeling of bitterness and good quality. It also works well with hard colors in a gradation of tones.

Note: The words in brackets were taken from another database of 180 words, not shown in this book.

BG/V
Peacock Green

Widely used in...
Fashion
Interior Design
Product Design
Visual Media ★★

Lifestyle...
Casual
Modern

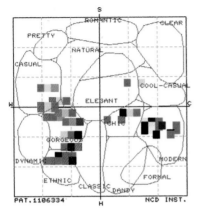

Typical Color Combination Images

progressive···★
showy··★
modern··★
sharp··★
vigorous··★
sporty···★
casual···★
active··★

agile, speedy, dynamic and active, bold, intense, provocative

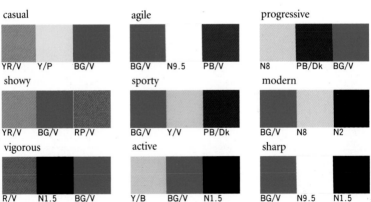

casual
YR/V Y/P BG/V

agile
BG/V N9.5 PB/V

progressive
N8 PB/Dk BG/V

showy
YR/V BG/V RP/V

sporty
BG/V Y/V PB/Dk

modern
BG/V N8 N2

vigorous
R/V N1.5 BG/V

active
Y/B BG/V N1.5

sharp
BG/V N9.5 N1.5

The combination of white and peacock green can be seen in the shopping streets of Jiyugaoka, one of the most fashionable areas of Tokyo, and is also often seen in Kobe and Yokohama. It has a sharp, modern, Western image.

When this shade is combined with cool colors, such as white or black, the effect is sporty, agile, and progressive. The cool quality of such color combinations seems to appeal to Japanese people these days.

Combined with contrasting shades, such as red or yellow, it conveys a vigorous, active impression, bold and showy.

BG/S
Jewel Green

Widely used in...

Fashion	★★
interior Design	
Product Design	★★★
Visual Media	★

Lifestyle...

Casual
Modern

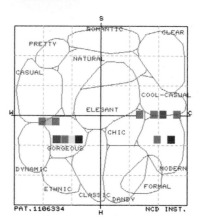

Typical Color Combination Images

agile, sharp, sporty, provocative, tropical, active

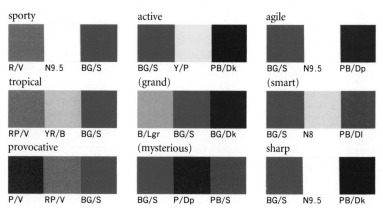

sporty

| R/V | N9.5 | BG/S |

active

| BG/S | Y/P | PB/Dk |

agile

| BG/S | N9.5 | PB/Dp |

tropical

| RP/V | YR/B | BG/S |

(grand)

| B/Lgr | BG/S | BG/Dk |

(smart)

| BG/S | N8 | PB/Dl |

provocative

| P/V | RP/V | BG/S |

(mysterious)

| BG/S | P/Dp | PB/S |

sharp

| BG/S | N9.5 | PB/Dk |

Clear tones convey the character and beauty of the blue green hue most successfully. For all the hues, strong tones have a slightly dull quality and therefore convey a different image from that of the clear, vivid tones. But for this color group the change in image as the tone becomes duller tends to be for the worse, and for this reason care should be taken to minimize its dullness when making color combinations with this shade.

Note: The color combinations in brackets are not part of the test data, and have been included for reference purposes only. Please use them as further ideas for color combinations.

BG/B
Turquoise

Widely used in...

Fashion
Interior Design
Product Design ★★
Visual Media ★★

Lifestyle...

Casual
Modern

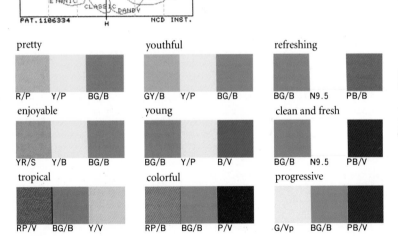

Typical Color Combination Images

young ···································· ★★
tropical ··································· ★★
clean and fresh ····················· ★★
refreshing ····························· ★★
colorful ································· ★★
progressive ··························· ★★
pretty, childlike ····················· ★
youthful, enjoyable ················· ★
fresh and young, speedy ··········· ★
Western ································· ★

pretty

| R/P | Y/P | BG/B |

youthful

| GY/B | Y/P | BG/B |

refreshing

| BG/B | N9.5 | PB/B |

enjoyable

| YR/S | Y/B | BG/B |

young

| BG/B | Y/P | B/V |

clean and fresh

| BG/B | N9.5 | PB/V |

tropical

| RP/V | BG/B | Y/V |

colorful

| RP/B | BG/B | P/V |

progressive

| G/Vp | BG/B | PB/V |

This shade, which takes its name from the turquoise stone, has recently come into more widespread use in Japan, perhaps because its pure, clear, qualities give it a special appeal for the Japanese. Its image is cool and refreshing, the antithesis of a sweaty, heavy image.

Combined with cool colors it is young, clean, and fresh and creates a refreshing, progressive impression. Warm colors accentuate its blue green hue, giving a colorful, enjoyable, pretty effect.

BG/P

Light Aqua Green

Widely used in...

Fashion	★
Interior Design	★
Product Design	★
Visual Media	★

Lifestyle...

Casual
Natural

Typical Color Combination Images

clean	★★★
neat	★★
clean and fresh	★★
Western	★★
fresh and young	★★
healthy	★★
pure	★
cultivated	★

crystalline, refreshing, pure and simple, fresh, clear, agile

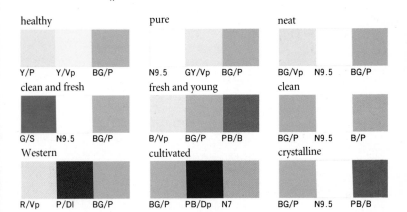

healthy

Y/P	Y/Vp	BG/P

pure

N9.5	GY/Vp	BG/P

neat

BG/Vp	N9.5	BG/P

clean and fresh

G/S	N9.5	BG/P

fresh and young

B/Vp	BG/P	PB/B

clean

BG/P	N9.5	B/P

Western

R/Vp	P/Dl	BG/P

cultivated

BG/P	PB/Dp	N7

crystalline

BG/P	N9.5	PB/B

The clean and refreshing image of light aqua green appeals to both men and women, young and middle aged. This wide appeal probably accounts for the increasing popularity of this shade and of aqua blue.

With white and blue, light aqua green conveys a neat, clean, fresh image, while with lemon yellow or pink it is pleasant, fresh, young and healthy. The addition of purple adds a stylish touch. But the most important thing when creating color combinations with this shade is to bring out the beauty of its clear tone.

BG/Vp
Horizon Blue

Widely used in...
Fashion
Interior Design
Product Design ★
Visual Media

Lifestyle...
Romantic
Casual
Natural

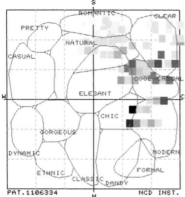

Typical Color Combination Images

neat·· ★★★
pure·· ★★
soft··· ★
crystalline·· ★
supple··· ★
dreamy·· ★
gentle·· ★
steady·· ★
clean··· ★
pure and elegant·· ★

supple

| R/Vp | N9 | BG/Vp |

pure

| BG/Vp | N9.5 | PB/Vp |

neat

| BG/Vp | N9.5 | BG/P |

soft

| YR/Vp | BG/Vp | GY/Vp |

dreamy

| BG/Vp | P/Vp | PB/Lgr |

clean

| BG/Vp | N9.5 | PB/P |

gentle

| YR/Lgr | BG/Vp | Y/Vp |

steady

| BG/Vp | B/P | B/Dl |

crystalline

| BG/Vp | N9.5 | PB/B |

Cool and soft, horizon blue has a steady and gentle image, with a cultured feeling.

This color has the refreshing quality of sherbet, and it conveys an air of neatness. As its tone is pure, innocent and supple, it has a dreamy effect that suits the Japanese taste. When combined with warm, soft colors, it is romantic and creates a dream-like atmosphere. When making color combinations with this shade, care should be taken to preserve its soft, clear quality.

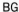

BG/Lgr
Eggshell Blue

Widely used in...

Fashion ★
Interior Design ★
Product Design
Visual Media

Lifestyle...

Chic
Natural

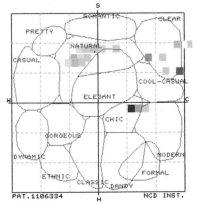

Typical Color Combination Images

lighthearted ···★

pretty, tender, friendly, pure, simple, neat, peaceful, stylish

pretty

RP/P Y/Vp BG/Lgr

tender

RP/P RP/Vp BG/Lgr

lighthearted

YR/B BG/Lgr Y/P

peaceful

YR/Lgr Y/Vp BG/Lgr

friendly

YR/L Y/Lgr BG/Lgr

stylish

P/Dl N6 BG/Lgr

neat

BG/Lgr N9.5 B/P

simple

BG/Lgr N9.5 PB/L

pure

N9.5 BG/Lgr PB/B

It is important to consider whether a shade is clear or dull when you wish to use it to convey a particular image. The gray in this shade changes it from a clear to a dull color, and although it has only a hint of gray compared to horizon blue, the images of the two are completely dif-ferent. Eggshell blue no longer has a crystalline quality, but instead is stylish and light.

However, horizon blue and eggshell blue do share some common attributes—for example, they can both convey a neat image. This is be-cause both are soft colors and similar in tone.

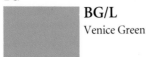

BG/L
Venice Green

Widely used in...

Fashion	★★
Interior Design	
Product Design	★
Visual Media	★★

Lifestyle...

Natural
Casual

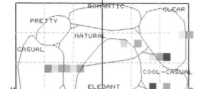

Typical Color Combination Images

cultivated···★

fresh, young, dewy, casual, mysterious, amusing, Western, steady

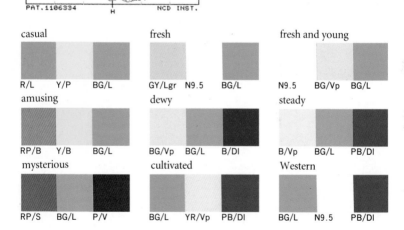

casual

| R/L | Y/P | BG/L |

fresh

| GY/Lgr | N9.5 | BG/L |

fresh and young

| N9.5 | BG/Vp | BG/L |

amusing

| RP/B | Y/B | BG/L |

dewy

| BG/Vp | BG/L | B/Dl |

steady

| B/Vp | BG/L | PB/Dl |

mysterious

| RP/S | BG/L | P/V |

cultivated

| BG/L | YR/Vp | PB/Dl |

Western

| BG/L | N9.5 | PB/Dl |

Venice green has a watery quality that has a special significance for the Japanese. In Japan it is said that water is a symbol of culture, but it is also associated with youth and freshness. This dual character is apparent in the images that can be conveyed by this shade.

With white or dark blue, the effect is steady and Western, while with warm colors it has a casual feel. It can, however, also convey a refined, distinguished, intelligent atmosphere.

Although this shade lacks the brilliance of the bright tones, its light tone gives it a calm quality. It also contains more yellow tint than its counterpart in the blue color group (B/L), and this gives it a slightly warm feel.

BG/Gr
Blue Spruce

Widely used in...

Fashion
Interior Design
Product Design
Visual Media

Lifestyle...

Chic
Elegant

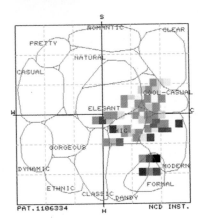

PAT. 1106334 NCD INST.

Typical Color Combination Images

distinguished·······························★★
noble···★★
aqueous···★★
dewy··★

quiet, chic, sober, intellectual, urban, fashionable

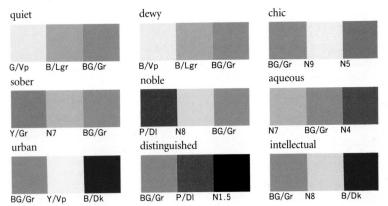

quiet

G/Vp B/Lgr BG/Gr

dewy

B/Vp B/Lgr BG/Gr

chic

BG/Gr N9 N5

sober

Y/Gr N7 BG/Gr

noble

P/Dl N8 BG/Gr

aqueous

N7 BG/Gr N4

urban

BG/Gr Y/Vp B/Dk

distinguished

BG/Gr P/Dl N1.5

intellectual

BG/Gr N8 B/Dk

The upper side of a leaf is shiny and glossy, whereas the other side is shadowy and does not reflect light. This shade takes its Japanese name from the underside of a leaf. It has a shadowy, grayish tone, and a delicate hue.

Distinguished, intellectual, chic, and fashionable, it is readily accepted by people who live in an urban environment. This polished, grayish tone has a self-effacing character and a quiet, confidential quality. As it has a moist feel, it goes well with soft grays or slightly hard purples, and gives a noble effect.

BG/Dl
Cambridge Blue

Widely used in...

Fashion ★★
Interior Design
Product Design
Visual Media ★★

Lifestyle...

Classic
Modern

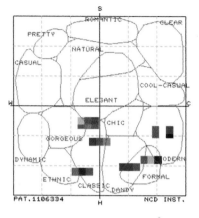

Typical Color Combination Images

decorative ·· ★★
complex ··· ★

modern, smart, exact, elaborate, mysterious

(ethnic)

RP/Dl BG/Dl Y/S

exact

BG/Dl N6 PB/Dgr

smart

BG/Dl N9.5 PB/Dp

decorative

P/Dk RP/S BG/Dl

mysterious

P/V RP/S BG/Dl

modern

BG/Dl N9.5 P/Dgr

elaborate

R/Dp P/Dk BG/Dl

complex

GY/Dk P/Dl BG/Dl

(magnificent)

B/Lgr BG/Dl B/Dk

There are many names for shades of a blue hue from the blue green, blue, and purple blue color groups. Cambridge blue, prussian blue, and peacock blue are some examples. This is probably because we are surrounded by blue shades in our everyday lives.

Although Cambridge blue has blue in its name, it looks greenish. It is a fairly dark shade

with a strong character. Depending on the colors combined with it, Cambridge blue can convey a mysterious or a fashionable effect.

Note: The color combinations in brackets are not part of the data and have been included for reference purposes only. Please use them as further ideas for color combinations.

BG/Dp
Prussian Green

Widely used in...

Fashion
Interior Design
Product Design
Visual Media ★★

Lifestyle...

Casual
Dandy

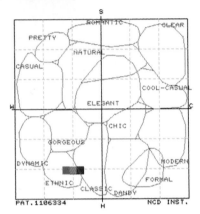

Typical Color Combination Images

wild

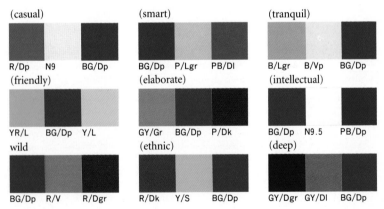

(casual)

| R/Dp | N9 | BG/Dp |

(friendly)

| YR/L | BG/Dp | Y/L |

wild

| BG/Dp | R/V | R/Dgr |

(smart)

| BG/Dp | P/Lgr | PB/Dl |

(elaborate)

| GY/Gr | BG/Dp | P/Dk |

(ethnic)

| R/Dk | Y/S | BG/Dp |

(tranquil)

| B/Lgr | B/Vp | BG/Dp |

(intellectual)

| BG/Dp | N9.5 | PB/Dp |

(deep)

| GY/Dgr | GY/Dl | BG/Dp |

This deep green shade, seen in the forests and in the depths of the mountains, has a wild image. It also conveys a feeling of intelligence, sternness, and accuracy. When combined with black or gray, it becomes deeper and more solemn.

In feudal Japan, the shade was often used by Samurai because of its masculine image. It can also give a quiet and sophisticated effect, and can appear subtle and mysterious.

Note: The color combinations in brackets are not part of the test data, and have been included for reference purposes only. Please use them as further ideas for color combinations.

BG

BG/Dk
Teal Green

Widely used in...
Fashion
Interior Design
Product Design
Visual Media ★

Lifestyle...
Dandy
Classic

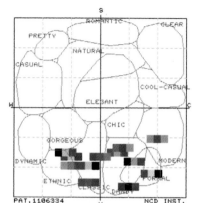

Typical Color Combination Images

ethnic·· ★
intrepid·· ★

untamed, elaborate, conservative, exact, majestic, metallic, diligent

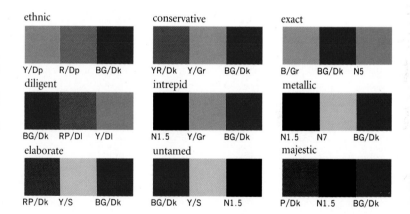

ethnic
Y/Dp R/Dp BG/Dk

conservative
YR/Dk Y/Gr BG/Dk

exact
B/Gr BG/Dk N5

diligent
BG/Dk RP/Dl Y/Dl

intrepid
N1.5 Y/Gr BG/Dk

metallic
N1.5 N7 BG/Dk

elaborate
RP/Dk Y/S BG/Dk

untamed
BG/Dk Y/S N1.5

majestic
P/Dk N1.5 BG/Dk

Dark tones convey a diligent and elaborate image. When black or gray is set between two dark tones, the impression is formal and metallic. Compared to black, teal green is more shadowy, and lacks a modern feeling.

The combination of teal green with strong tones of yellow or warm colors like brown creates an ethnic, elaborate atmosphere, while with purple the effect is majestic. In general, this shade conveys a hard image, and its coolness tightens up the color combinations it is used in.

BG

BG/Dgr
Dusky Green

Widely used in...

Fashion ★★★
Interior Design
Product Design
Visual Media

Lifestyle...

Dandy
Classic

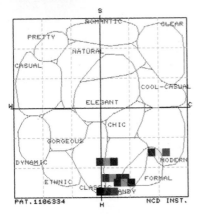

PAT. 1106334

NCD INST.

Typical Color Combination Images

classic··· ★

masculine, serious, sturdy, heavy and deep, placid

(calm)

YR/Lgr	Y/Gr	BG/Dgr

classic

R/Dgr	YR/Gr	BG/Dgr

(untamed)

BG/Dgr	R/Dp	N1.5

(magnificent)

BG/Gr	BG/Dl	BG/Dgr

sturdy

P/Dgr	Y/Gr	BG/Dgr

heavy and deep

BG/Dgr	Y/Dk	B/Dgr

masculine

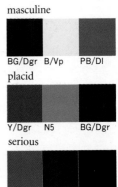

BG/Dgr	B/Vp	PB/Dl

placid

Y/Dgr	N5	BG/Dgr

serious

YR/Dk	BG/Dgr	N1.5

Dusky green has a serious, heavy, deep image, and its cool quality can be used to create a masculine feel. The combination of dusky green with brown or gray gives a classic, placid impression. As it looks hard and sturdy, a practical image can easily be created with this shade. It can also convey images that black is unable to convey—sophisticated, dignified and quiet, even sublime. When its hard quality is used as the basis of a color combination, a tasteful, fashionable effect can be achieved.

Note: The color combinations in brackets are not part of the test data, and have been included for reference purposes only. Please use them as further ideas for color combinations.

B/V
Cerulean Blue

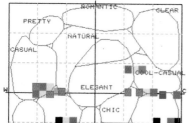

Widely used in...

Fashion
Interior Design
Product Design ★
Visual Media ★★

Lifestyle...

Casual
Modern

Typical Color Combination Images

active ·· ★★
showy ··· ★
speedy ·· ★
sporty ··· ★
vivid ·· ★

flamboyant, young, tropical sharp, bold, provocative

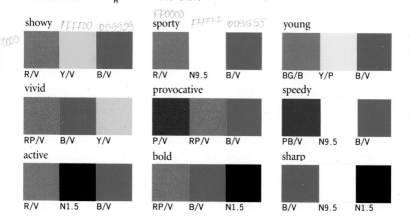

showy			sporty			young		
R/V	Y/V	B/V	R/V	N9.5	B/V	BG/B	Y/P	B/V

vivid			provocative			speedy		
RP/V	B/V	Y/V	P/V	RP/V	B/V	PB/V	N9.5	B/V

active			bold			sharp		
R/V	N1.5	B/V	RP/V	B/V	N1.5	B/V	N9.5	N1.5

Blue tones have a sky-blue hue, whereas purple-blue tones are closer to sea blue. The clarity of cerulean blue gives it a refreshing and agile appearance. When combined with white or the ~~nge~~ of colors, an impression of sporti-~~l~~ speed emerges.

Alternatively, with red or yellow this cool sky-blue tone produces a contrasting blend of colors that conveys a provocative and showy effect. It is also fairly easy to create bold, flamboyant, or young images with this color.

B

B/S
Light Blue

Widely used in...

Fashion
Interior Design
Product Design ★★
Visual Media ★

Lifestyle...

Casual
Modern

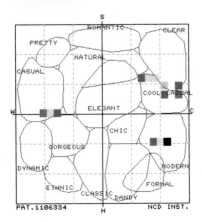

Typical Color Combination Images

modern, simple, smart, young, casual

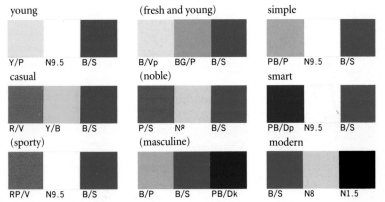

young			(fresh and young)			simple		
Y/P	N9.5	B/S	B/Vp	BG/P	B/S	PB/P	N9.5	B/S

casual			(noble)			smart		
R/V	Y/B	B/S	P/S	Nº	B/S	PB/Dp	N9.5	B/S

(sporty)			(masculine)			modern		
RP/V	N9.5	B/S	B/P	B/S	PB/Dk	B/S	N8	N1.5

Compared with other colors, the clear and dull tones of the blue range of colors are very similar, and the images conveyed by the strong and vivid tones do not widely differ. For this reason, it is easier to use the clear, vivid blues than the strong blues.

When light blue is combined with cool colors, it creates a modern, simple, and smart ef-fect. With the warm range of colors it looks enjoyable and casual.

Note: The color combinations in brackets are not part of the test data and have been in-cluded for reference purposes only. Please use them to develop ideas for color combinations.

B

B/B
Sky Blue

Widely used in...

Fashion	★
Interior Design	
Product Design	★★
Visual Media	★★

Lifestyle...

Casual
Modern

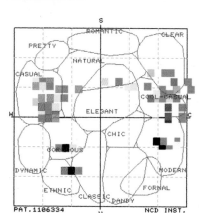

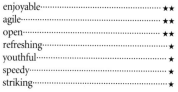

Typical Color Combination Images

enjoyable··············	★★
agile··············	★★
open··············	★★
refreshing··············	★
youthful··············	★
speedy··············	★
striking··············	★

crystalline, fresh, clear, healthy, modern, sharp

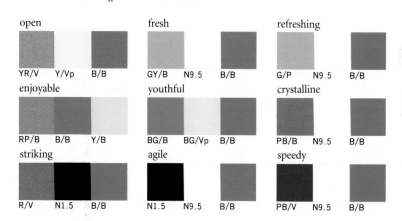

open
YR/V Y/Vp B/B

fresh
GY/B N9.5 B/B

refreshing
G/P N9.5 B/B

enjoyable
RP/B B/B Y/B

youthful
BG/B BG/Vp B/B

crystalline
PB/B N9.5 B/B

striking
R/V N1.5 B/B

agile
N1.5 N9.5 B/B

speedy
PB/V N9.5 B/B

This color evokes the image of a serene sky and, when combined with white or cool colors, it has a refreshing and agile appearance, with a feeling of clarity and speed. When combined with red or yellow, together with colors like orange, sky blue has an open, youthful image, fresh and enjoyable.

Mixing clear colors together in this way accentuates their clarity. Sky blue is often used with white in business due to the vivid impression created by the color combination.

B/P
Aqua Blue

Widely used in...

Fashion	★
Interior Design	
Product Design	★
Visual Media	★★

Lifestyle...

Casual
Romantic

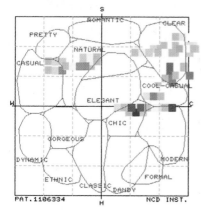

Typical Color Combination Images

clean	★★★★★
cute	★★
clear	★★
childlike	★★
crystalline	★
peaceful	★
smart	★
simple	★
clean and fresh	★

peaceful

YR/P	Y/Vp	B/P

clear

G/Vp	N9.5	B/P

crystalline

B/Vp	N9.5	B/P

cute

R/P	Y/P	B/P

simple

B/Gr	N9.5	B/P

clean

PB/P	N9.5	B/P

childlike FFFFCC

R/B	Y/Vp	B/P

FF9966 CCFFFF

clean and fresh

BG/B	N9.5	B/P

smart

PB/B	N9.5	B/P

Aqua blue possesses qualities that reflect a clean, clear, crystalline, and refreshing image.

When it is combined with cool tones, with white used as a separating color, a naturally simple appearance can be conveyed. With the clear tones of warm colors, it takes on a cute and childlike quality. It can also create a sense of coolness and casualness.

As the properties of this serene, clear color are in direct contrast to those of the dull colors, it is difficult to mix them, and they are rarely seen together.

B

B/Vp
Pale Blue

Widely used in...

Fashion	★
Interior Design	★
Product Design	★★★
Visual Media	

Lifestyle...

Romantic
Casual

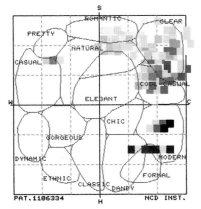

Typical Color Combination Images

clear	★★★
pure	★★★
dreamy	★★★
crystalline, fresh and young	★★
pure and simple, refreshing	★★
charming, romantic	★★
pure and elegant, neat	★★
dewy	★★
delicate	★
gentle	★
tranquil	★

charming

RP/P	RP/Vp	B/Vp

romantic

RP/Vp	N9.5	B/Vp

clear

BG/P	N9.5	B/Vp

dreamy

RP/P	B/Vp	Y/Vp

crystalline

B/Vp	N9.5	B/P

pure

B/Vp	N9.5	PB/B

pure and simple

P/P	B/Vp	YR/Vp

fresh and young

BG/B	B/Vp	N9.5

refreshing

B/Vp	N9.5	B/B

Pale blue can be even more cool and clear than white. Its qualities of clearness and purity are accentuated when it is combined with white and the third group of cool-soft colors, and it can also project a dreamy, romantic image. This color has a charming, simple appeal.

Pale blue does not go well with hard tones, which tend to detract from its clearness.

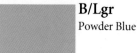

B/Lgr
Powder Blue

Widely used in...

Fashion	★
Interior Design	★★
Product Design	★
Visual Media	★

Lifestyle...

Chic
Modern

Typical Color Combination Images

dewy	★★
pure and simple	★
quiet	★
distinguished	★
polished	★
salty	★
eminent	★

urban, sharp, rational, delicate, gentle, grand

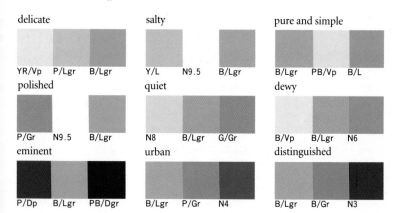

delicate
YR/Vp P/Lgr B/Lgr

salty
Y/L N9.5 B/Lgr

pure and simple
B/Lgr PB/Vp B/L

polished
P/Gr N9.5 B/Lgr

quiet
N8 B/Lgr G/Gr

dewy
B/Vp B/Lgr N6

eminent
P/Dp B/Lgr PB/Dgr

urban
B/Lgr P/Gr N4

distinguished
B/Lgr B/Gr N3

In contrast to the dry effect of the clear, very pale tones, the light grey tones have a dewy quality. As it is slightly dull, powder blue can convey images that are quiet, distinguished, polished, and delicate.

Combined with soft tones this color appears quiet; with hard tones it creates an eminent and refined atmosphere.

B/L
Aquamarine

Widely used in...

Fashion	★
Interior Design	★
Product Design	
Visual Media	★★

Lifestyle...

Chic
Casual

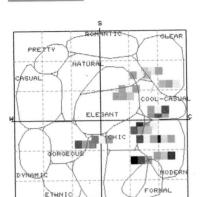

PAT. 1106334

Typical Color Combination Images

pure and simple·······································★
intellectual···★

stylish, smart, interesting, urban, precise,
peaseful, noble and elegant

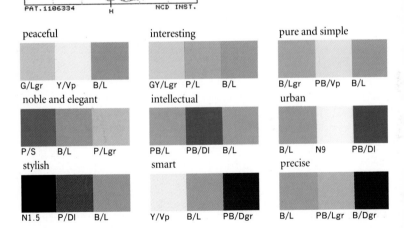

peaceful

G/Lgr Y/Vp B/L

interesting

GY/Lgr P/L B/L

pure and simple

B/Lgr PB/Vp B/L

noble and elegant

P/S B/L P/Lgr

intellectual

PB/L PB/Dl B/L

urban

B/L N9 PB/Dl

stylish

N1.5 P/Dl B/L

smart

Y/Vp B/L PB/Dgr

precise

B/L PB/Lgr B/Dgr

Even though aquamarine has a dull light tone, in contrast to the clear hue of the pale tones, the images it presents do not widely differ from those of the cool shades, except that aquamarine has a more interesting and graceful appearance. Also, the polished look of the pale tones is re-placed by a sense of stylishness.

As a culture becomes more sophisticated, dull shades are perceived as more tasteful than clear colors.

The combination of this color with purple achieves an attractive and fashionable effect.

B

B/Gr
Blue Gray

Widely used in...

Fashion	★
Interior Design	★
Product Design	
Visual Media	

Lifestyle...

Chic
Modern
Elegant

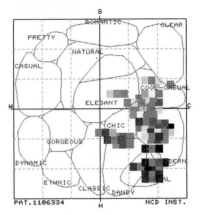

Typical Color Combination Images

precise	★★
distinguished	★★
quiet	★★
authoritative	★★
solemn	★
sublime	★
dignified	★
exact	★
composed	★
dewy	★
salty	★
aqueous	★

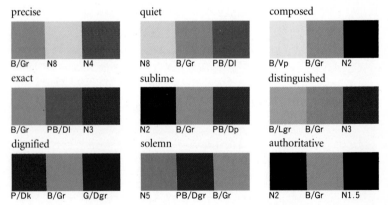

precise
B/Gr · N8 · N4

quiet
N8 · B/Gr · PB/Dl

composed
B/Vp · B/Gr · N2

exact
B/Gr · PB/Dl · N3

sublime
N2 · B/Gr · PB/Dp

distinguished
B/Lgr · B/Gr · N3

dignified
P/Dk · B/Gr · G/Dgr

solemn
N5 · PB/Dgr · B/Gr

authoritative
N2 · B/Gr · N1.5

Blue gray is fairly dark and is often combined with other dark, mainly grayish tones. Even cold colors can develop a dewy effect when they are this dark. The color projects a sense of reservation and composure.

The combination of blue gray with light gray evokes a distinguished and dignified image, while with black or deep purple it has a sublime, authoritative appearance. It has qualities that reflect precision and exactness, and it is commonly used to convey a solemn and quiet impression.

B

B/Dl
Shadow Blue

Widely used in...

Fashion	★★
Interior Design	★
Product Design	
Visual Media	★★

Lifestyle...

Dandy
Modern
Chic

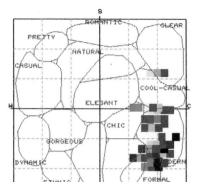

Typical Color Combination Images

exact ·· ★★
practical ··· ★
precise ··· ★
rational ·· ★
composed ·· ★

masculine, urban, modern, sober, sublime, distinguished

sober
PB/P PB/Gr B/Dl

urban
N5 N9.5 B/Dl

rational
B/Dl N9 PB/Dp

exact
N4 BG/Gr B/Dl

composed
N8 B/Dl N1.5

modern
B/Dl N9.5 N2

practical
Y/Gr B/Dl N2

masculine
GY/Dgr N6 B/Dl

precise
B/Dl PB/Lgr PB/Dk

Shadow blue has a subdued, dull tone, and as it contains a lot of gray, the attractive tone effects produced when it is combined with light gray, medium gray, or dark gray give it a fashionable appearance. Moderate and sober in character, it conveys images that are precise and composed.

When white is used as a separating color in combinations, the impression created is modern and reserved.

B

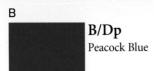

B/Dp
Peacock Blue

Widely used in...
Fashion
Interior Design
Product Design
Visual Media

Lifestyle...
Modern
Casual
Dandy

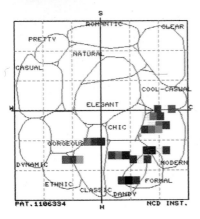

Typical Color Combination Images

agile, metallic, precise, composed, masculine, intrepid, ethnic, mature, precious, mysterious

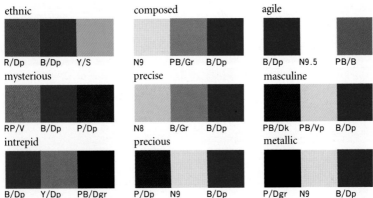

ethnic

R/Dp B/Dp Y/S

composed

N9 PB/Gr B/Dp

agile

B/Dp N9.5 PB/B

mysterious

RP/V B/Dp P/Dp

precise

N8 B/Gr B/Dp

masculine

PB/Dk PB/Vp B/Dp

intrepid

B/Dp Y/Dp PB/Dgr

precious

P/Dp N9 B/Dp

metallic

P/Dgr N9 B/Dp

This color was favored by the samurai, probably because the properties it possesses (masculinity, agility, formality) appealed to them. Nowadays, peacock blue is often used in business due to the metallic effect it conveys and its qualities of precision and composure, which are appropriate to the working environment.

Effective images can be created when the color's coolness is emphasized. On the other hand, when it is combined with red or yellow and purple is added, peacock blue can give quite an unconventional impression. Care should be taken with this color, as it can assume rather unusual qualities.

B

B/Dk
Teal

Widely used in...
Fashion
Interior Design
Product Design
Visual Media

Lifestyle...
Dandy
Modern

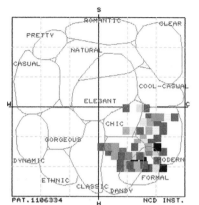

PAT. 1106334 NCD INST.

Typical Color Combination Images

intellectual··★★
dapper··★★
masculine··★
urban···★
rational···★
earnest···★

conservative, dignified, exact, sporty, composed, metallic

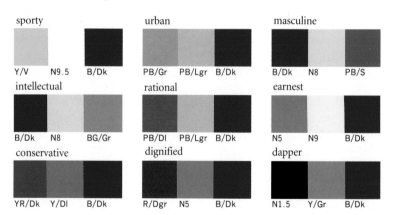

sporty
Y/V N9.5 B/Dk

urban
PB/Gr PB/Lgr B/Dk

masculine
B/Dk N8 PB/S

intellectual
B/Dk N8 BG/Gr

rational
PB/Dl PB/Lgr B/Dk

earnest
N5 N9 B/Dk

conservative
YR/Dk Y/Dl B/Dk

dignified
R/Dgr N5 B/Dk

dapper
N1.5 Y/Gr B/Dk

Teal is darker and deeper in tone than peacock blue, and this gives it a more severe and masculine character as well as enhances its intellectual and dapper qualities. The impression conveyed is cool and dark.

However, an urbane and rational image can be conveyed when a soft gray or a light tone is used as a separating color in combinations. With brown, teal takes on a calm quality; when showy colors, such as yellow, are used as an accent, yet other images emerge.

B

B/Dgr
Prussian Blue

Widely used in...

Fashion
Interior Design
Product Design ★★
Visual Media

Lifestyle...

Dandy
Modern
Classic

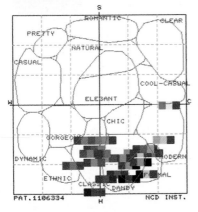

PAT.1106334

NCD INST.

Typical Color Combination Images

dapper ···★
robust ···★

solemn, heavy and deep, progressive, practical, sublime, precise, strong and robust

practical
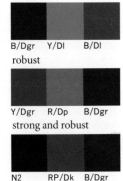

| B/Dgr | Y/Dl | B/Dl |

sublime

| Y/Gr | P/Dl | B/Dgr |

progressive
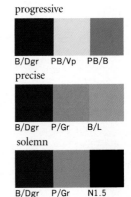

| B/Dgr | PB/Vp | PB/B |

robust

| Y/Dgr | R/Dp | B/Dgr |

dapper

| Y/Dgr | Y/Gr | B/Dgr |

precise

| B/Dgr | P/Gr | B/L |

strong and robust

| N2 | RP/Dk | B/Dgr |

heavy and deep

| BG/Dgr | Y/Dk | B/Dgr |

solemn

| B/Dgr | P/Gr | N1.5 |

Although a lot of blue tint is used to produce this color, its dark gray tone makes it difficult to distinguish from black. However, black does not have the sublime, dignified, and solemn qualities of Prussian blue. The difference is that black is a clear color, but dark gray tones are perceived as dull tones with a faint nuance of color. Prussian blue can also convey a dandy impression.

PB/V

Ultramarine

Widely used in...

Fashion	★
Interior Design	
Product Design	★
Visual Media	★★★

Lifestyle...

Casual
Modern

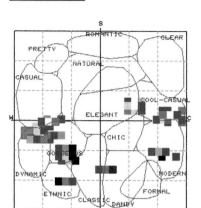

Typical Color Combination Images

lively	★★★★
speedy	★★★★
agile	★★★
vigorous	★★
striking	★★
progressive	★
clean and fresh	★

young, sporty, sharp, active, vivid, intense

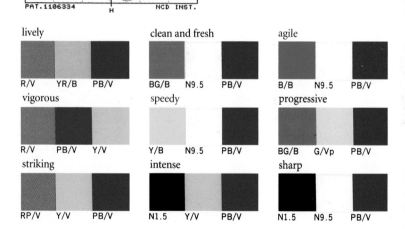

lively
R/V YR/B PB/V

clean and fresh
BG/B N9.5 PB/V

agile
B/B N9.5 PB/V

vigorous
R/V PB/V Y/V

speedy
Y/B N9.5 PB/V

progressive
BG/B G/Vp PB/V

striking
RP/V Y/V PB/V

intense
N1.5 Y/V PB/V

sharp
N1.5 N9.5 PB/V

The combination of ultramarine with white conveys an impression of speed and is often used for express trains and airplanes. The agile feeling of this color is similar to that of the blue tones.

As purple-blue shades have more of a red nuance than blue tones, the contrast produced when they are combined with red gives a stronger impact, but it also creates an intimate atmosphere. For this reason the purple-blue shades are used more frequently in everyday life. As the color projects a progressive image, it often appears in national flags.

PB/S
Sapphire

Widely used in...

Fashion	★★
Interior Design	★
Product Design	★★★
Visual Media	★★★

Lifestyle...

Modern
Casual

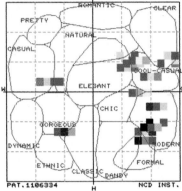

PAT.1106334

Typical Color Combination Images

young ·· ★★
refreshing ··· ★
intellectual ·· ★
masculine ··· ★

youthful, urban, rational, pure, neat, steady

youthful
| Y/P | N9.5 | PB/S |

neat
| N9.5 | BG/Vp | PB/S |

pure
| PB/S | N9.5 | B/Vp |

young
| Y/P | BG/P | PB/S |

urban
| PB/L | PB/Vp | PB/S |

refreshing
| PB/S | N9.5 | B/B |

steady
| G/P | Y/Vp | PB/S |

masculine
| PB/Lgr | PB/S | N1.5 |

intellectual
| N1.5 | N9.5 | PB/S |

The color sapphire dates back to the time of the silk road. Even now it reminds people of that era. The image created by this cultivated shade is idealistic and full of hope for the future. As it has intellectual, masculine, and intelligent qualities, sapphire is used in retail to give an ac- cent to interiors or in exterior signs. It conveys a youthful impression, has a neat, steady, rational appearance, and suits Japanese skin color when used for business clothing. This is one of the basic colors of everyday life.

PB/B
Salvia Blue

Widely used in...

Fashion ★
Interior Design
Product Design ★★★
Visual Media

Lifestyle...

Casual
Modern

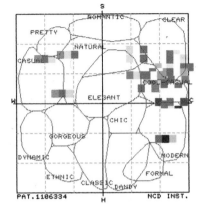

PAT. 1106334 NCD INST.

Typical Color Combination Images

crystalline·················· ★★★
refreshing·················· ★★★
youthful·················· ★★
clear·················· ★★
pure·················· ★★
fresh·················· ★
progressive·················· ★
fresh and young·················· ★
smart·················· ★
clean and fresh·················· ★
Western·················· ★

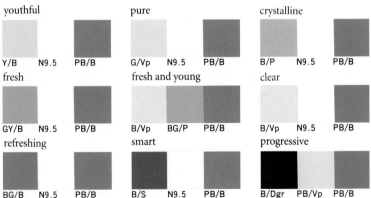

youthful
Y/B N9.5 PB/B

pure
G/Vp N9.5 PB/B

crystalline
B/P N9.5 PB/B

fresh
GY/B N9.5 PB/B

fresh and young
B/Vp BG/P PB/B

clear
B/Vp N9.5 PB/B

refreshing
BG/B N9.5 PB/B

smart
B/S N9.5 PB/B

progressive
B/Dgr PB/Vp PB/B

The name of this color was probably chosen because of the crystalline and refreshing image conveyed by the blue salvia flower.

The bright tones are also known as the jewelry tones, and this bright color has a clear shine to it as well. The effect created is youthful, pure and fresh. Its freshness and stylishness are appealing, and it also projects a progressive image that inspires dreams for the future. Combined with white, it takes on a refreshing appearance, and yellow, red, or orange can be used as an accent to give a more lively impression.

PB/P
Sky Mist

Widely used in...

Fashion	★★
Interior Design	★
Product Design	
Visual Media	

Lifestyle...

Casual
Elegant

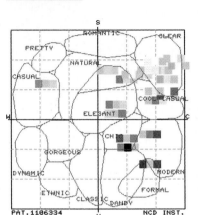

PAT.1106334

Typical Color Combination Images

refined	★★
simple	★★
pure and elegant	★★
polished	★
clean	★

refreshing, noble, distinguished, casual, sober, noble and elegant

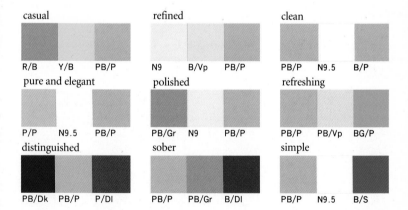

casual
R/B Y/B PB/P

refined
N9 B/Vp PB/P

clean
PB/P N9.5 B/P

pure and elegant
P/P N9.5 PB/P

polished
PB/Gr N9 PB/P

refreshing
PB/P PB/Vp BG/P

distinguished
PB/Dk PB/P P/Dl

sober
PB/P PB/Gr B/Dl

simple
PB/P N9.5 B/S

Even cool purple-blue tones lose their appeal if they are too shiny. The pale tone of sky mist acts as a counterbalance to its brightness, resulting in a refined and polished appearance. The sober and simple feel of this shade helps to project an atmosphere that is distinguished, noble and elegant. As its hue harmonizes well with both blue and purple, such combinations create a graceful and elegant effect. Together with white a clean, pure and elegant impression emerges. This color also goes well with lemon yellow.

PB/Vp
Pale Mist

Widely used in...

Fashion
Interior Design ★
Product Design ★
Visual Media

Lifestyle...

Romantic
Elegant
Chic

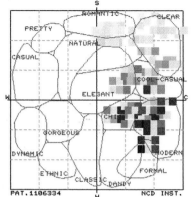

Typical Color Combination Images

light···★★★
romantic···★★★
emotional··★★
pure and simple··★★
dreamy···★★
composed···★★
polished···★★
sedate···★★
pure···★

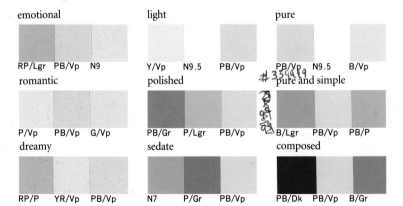

emotional

RP/Lgr PB/Vp N9

light

Y/Vp N9.5 PB/Vp

pure

PB/Vp N9.5 B/Vp

#359919

romantic

P/Vp PB/Vp G/Vp

polished

PB/Gr P/Lgr PB/Vp

pure and simple

B/Lgr PB/Vp PB/P

dreamy

RP/P YR/Vp PB/Vp

sedate

N7 P/Gr PB/Vp

composed

PB/Dk PB/Vp B/Gr

Because pale mist is a light tone, its purple hue is rather faint, which gives it a romantic and dreamy appearance. This image can be enhanced by combining it with other purple shades that have a light tone or a slight blue nuance.

It goes well with grayish colors, which bring out the sedate beauty and polished atmosphere that it creates.

PB/Lgr
Moonstone Blue

Widely used in...

Fashion	★★
Interior Design	★★
Product Design	
Visual Media	

Lifestyle...

Chic
Elegant
Romantic

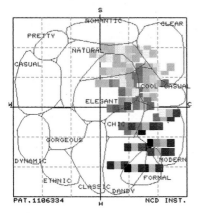

PAT. 1106334 NCD INST.

Typical Color Combination Images

subtle	★★★
delicate	★★
fashionable	★★
quiet	★★
urban, polished	★
precise, exact	★
noble and elegant, eminent	★
cultured, sedate	★
dewy, aqueous	★

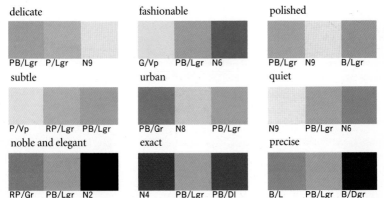

delicate
PB/Lgr P/Lgr N9

fashionable
G/Vp PB/Lgr N6

polished
PB/Lgr N9 B/Lgr

subtle
P/Vp RP/Lgr PB/Lgr

urban
PB/Gr N8 PB/Lgr

quiet
N9 PB/Lgr N6

noble and elegant
RP/Gr PB/Lgr N2

exact
N4 PB/Lgr PB/Dl

precise
B/L PB/Lgr B/Dgr

Japanese people devote many years to learning how to present images that are subtle, delicate, and exact.

Moonstone blue conveys a quiet and composed feeling. It is a cool color, and when used in place of light gray the effect of noble elegance, sedateness, and precision is accentuated. It has a neat quality that is very appealing.

PB/L
Pale Blue II

Widely used in...

		Lifestyle...
Fashion	★★	Elegant
Interior Design	★★	Chic
Product Design	★	Modern
Visual Media	★★	Casual

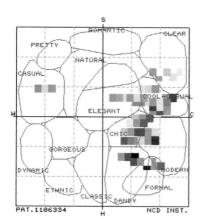

Typical Color Combination Images

crystalline	★
refined	★
intellectual	★
urban	★
smart	★
simple	★
aristocratic	★
pure and elegant	★

subtle and mysterious, elegant, sublime, enjoyable, rational, distinguished

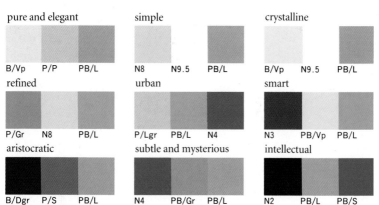

pure and elegant
B/Vp P/P PB/L

simple
N8 N9.5 PB/L

crystalline
B/Vp N9.5 PB/L

refined
P/Gr N8 PB/L

urban
P/Lgr PB/L N4

smart
N3 PB/Vp PB/L

aristocratic
B/Dgr P/S PB/L

subtle and mysterious
N4 PB/Gr PB/L

intellectual
N2 PB/L PB/S

This color has a crystalline and refined charm. Its smart quality is perhaps best appreciated by people of an intellectual disposition who have grown up in the city.

With white or light gray, pale blue takes on a simple and refined appearance. It goes well with the purple range of colors, creating a crystalline and graceful atmosphere. When skillfully combined with a purple or red-purple shade, it conveys an elegant impression. It is also easy to use this shade with the cool tones.

PB

PB/Gr
Slate Blue

Widely used in...		Lifestyle...
Fashion	★	Chic
Interior Design	★★	Elegant
Product Design	★★	Modern
Visual Media	★★	

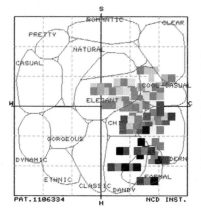

PAT. 1106334

NCD INST.

Typical Color Combination Images

refined	★★
chic	★★
urban	★★
majestic	★★
polished	★★
aqueous	★★
graceful, sleek	★
sober, aristocratic	★
precise, subtle	★
eminent, noble	★

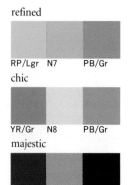

refined
RP/Lgr N7 PB/Gr

chic
YR/Gr N8 PB/Gr

majestic
P/Dk PB/Gr N2

graceful
P/Lgr P/L PB/Gr

polished
PB/Vp P/Lgr PB/Gr

urban
B/Lgr PB/Gr N4

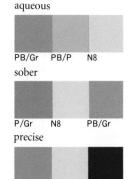

aqueous
PB/Gr PB/P N8

sober
P/Gr N8 PB/Gr

precise
PB/Gr N8 PB/Dk

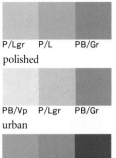

If you wish to create an elegant and graceful impression, this is a good shade to use. Reminiscent of a Japanese landscape in the mist, when used in combination with similar tones it has a polished, subtle feel and can produce a majestic, chic effect. With gray, cool or grayish tones, slate blue projects a refined quality.

PB/Dl
Shadow Blue

Widely used in...

Fashion	★★★
Interior Design	★
Product Design	★
Visual Media	★

Lifestyle...

Modern
Chic
Dandy
Casual

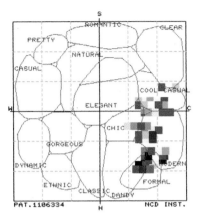

PAT.1106334 NCD INST.

Typical Color Combination Images

quiet	★★
cultivated	★★
masculine	★
modern	★
steady	★
Western	★

intellectual, progressive, precise, urban, fashionable, chic

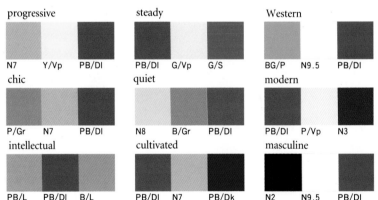

progressive
N7 Y/Vp PB/Dl

steady
PB/Dl G/Vp G/S

Western
BG/P N9.5 PB/Dl

chic
P/Gr N7 PB/Dl

quiet
N8 B/Gr PB/Dl

modern
PB/Dl P/Vp N3

intellectual
PB/L PB/Dl B/L

cultivated
PB/Dl N7 PB/Dk

masculine
N2 N9.5 PB/Dl

Similar to the grayish tones, shadow blue has a somber quality that gives a quiet and cultivated effect.

There is a reserved feel to this color; when blended with white and the clear blue colors, it creates a modern, intellectual, and intelligent impression. The contrast produced when combined with black and white gives it a masculine appearance, while a chic atmosphere can be achieved by combining it with gray or dull colors. This is an urbane shade often used in packaging to convey a sense of luxury.

PB/Dp
Mineral Blue

Widely used in...

Fashion	★
Interior Design	
Product Design	★★
Visual Media	★

Lifestyle...

Casual
Modern
Dandy

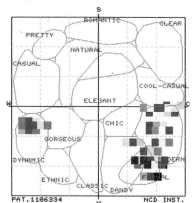

PAT.1106334

NCD INST.

Typical Color Combination Images

lively	★★
rational	★★
earnest	★★
masculine	★
composed	★
smart	★

agile, sporty, vigorous, sublime, exact, steady

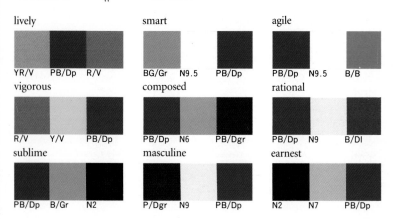

lively
YR/V PB/Dp R/V

smart
BG/Gr N9.5 PB/Dp

agile
PB/Dp N9.5 B/B

vigorous
R/V Y/V PB/Dp

composed
PB/Dp N6 PB/Dgr

rational
PB/Dp N9 B/Dl

sublime
PB/Dp B/Gr N2

masculine
P/Dgr N9 PB/Dp

earnest
N2 N7 PB/Dp

The purple-blue hue in the deep tones is much stronger than in the dull tones. Mineral blue differs from the four previous dull tones (pp. 111–114) in that it can present a sporty and lively impression when combined with showy warm colors. On the other hand, if white is used as a separating color in combinations, it can convey a rational and earnest image. It can also be used to project composed and sublime qualities.

PB

PB/Dk
Dark Mineral Blue

Widely used in...

Fashion	★★★
Interior Design	
Product Design	★★
Visual Media	★

Lifestyle...

Dandy
Modern
Casual

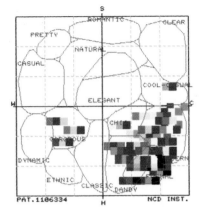

PAT.1106334

NCD INST.

Typical Color Combination Images

earnest	★★★
eminent	★★
sharp	★★
formal	★★
agile, intellectual	★
masculine, precise	★
distinguished, rational	★
authoritative, dapper	★
active, sound	★
intrepid, precious	★
Western	★

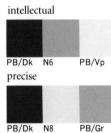

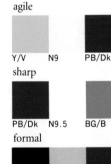

distinguished

P/Dl PB/P PB/Dk

intellectual

PB/Dk N6 PB/Vp

agile

Y/V N9 PB/Dk

eminent

B/Lgr P/Dl PB/Dk

precise

PB/Dk N8 PB/Gr

sharp

PB/Dk N9.5 BG/B

earnest

YR/Dk N6 PB/Dk

masculine

B/Dp PB/Vp PB/Dk

formal

N1.5 N7 PB/Dk

The general public is more familiar with this color than any other, apart from red and white. When compared with black, the purple-blue tone of dark mineral blue has a supple feel. Also this shade is not as formal as black, although it is often used in daily life as a semiformal color.

Combined with black, grey, or brown, it takes on a decidedly earnest appearance. In olden times Japanese people wore this color in everyday living and working, as it was considered physically and mentally stimulating.

PB/Dgr
Midnight Blue

Widely used in...

Fashion	★★
Interior Design	
Product Design	★★★
Visual Media	★

Lifestyle...

Dandy
Modern
Classic
Casual

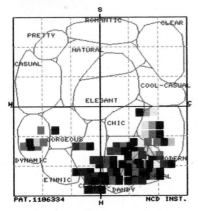

PAT. 1106334 NCD INST.

Typical Color Combination Images

dignified	★★★
solemn	★★
traditional	★★
strong and robust	★★
metallic	★★
authoritative	★★
proper	★★
heavy and deep, dapper	★
sturdy, serious	★
sound, intrepid	★

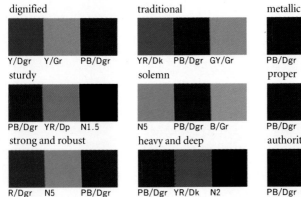

dignified
Y/Dgr Y/Gr PB/Dgr

traditional
YR/Dk PB/Dgr GY/Gr

metallic
PB/Dgr N9 N5

sturdy
PB/Dgr YR/Dp N1.5

solemn
N5 PB/Dgr B/Gr

proper
PB/Dgr N9 PB/Dp

strong and robust
R/Dgr N5 PB/Dgr

heavy and deep
PB/Dgr YR/Dk N2

authoritative
PB/Dgr B/Gr N2

Dark blue tones (including midnight blue) are used to imply victory in Japan, and are also known as winning colors. Although this shade, with its hint of black, is a quiet color, it has a supple, active feel.

When this color is combined with dark gray-ish brown or with gray, it projects a sturdy, strong and robust effect. On the other hand, when cool, light colors are used with it, midnight blue takes on an inorganic metallic appearance. It can also be used as a background color to accentuate the impact of showy colors.

P/V
Purple

Widely used in...

Fashion
Interior Design
Product Design
Visual Media ★★

Lifestyle...

Casual
Modern
Classic

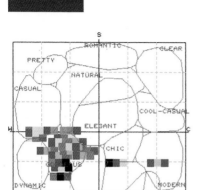

Typical Color Combination Images

fascinating··· ★★★
provocative·· ★★★
showy··· ★★
glossy··· ★★
mysterious··· ★★
decorative·· ★
amusing··· ★
dazzling··· ★

brilliant, colorful, gorgeous intense, tropical, noble and elegant

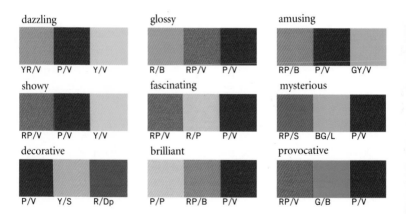

dazzling
YR/V P/V Y/V

glossy
R/B RP/V P/V

amusing
RP/B P/V GY/V

showy
RP/V P/V Y/V

fascinating
RP/V R/P P/V

mysterious
RP/S BG/L P/V

decorative
P/V Y/S R/Dp

brilliant
P/P RP/B P/V

provocative
RP/V G/B P/V

Shades of a purple hue are rather dull compared to the clear group of colors. This shade evokes the image of a cloudy valley. The vivid tones of purple are fascinating and glossy; they have a mysterious feel but can give a colorful effect when combined with other colors. Although purple is a showy color and lacks gracefulness, it can be combined with yellow or red to achieve a gorgeous effect. Alternatively, the addition of blue-green tones can bring out both the amusing and mysterious aspects of this shade.

P

P/S
Violet

Widely used in...

Fashion
Interior Design
Product Design
Visual Media ★★

Lifestyle...

Elegant
Classic

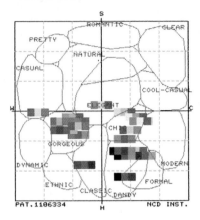

PAT.1106334 NCD INST.

Typical Color Combination Images

brilliant·································★★
glossy···································★★
precious·································★★
aristocratic·····························★★
elaborate································★
alluring··································★
noble and elegant····················★
mysterious······························★
eminent··································★

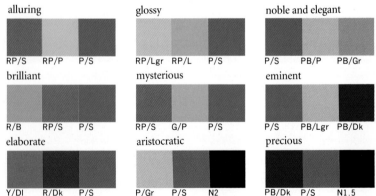

alluring

RP/S RP/P P/S

glossy

RP/Lgr RP/L P/S

noble and elegant

P/S PB/P PB/Gr

brilliant

R/B RP/S P/S

mysterious

RP/S G/P P/S

eminent

P/S PB/Lgr PB/Dk

elaborate

Y/Dl R/Dk P/S

aristocratic

P/Gr P/S N2

precious

PB/Dk P/S N1.5

Violet is a strong tone and although it does not have the brightness of the vivid tones it is both glossy and alluring, an elaborate and showy color. Of all the colors, it is most difficult to achieve a sporty effect with those of a purple hue, and this is even more true as the tone becomes duller, the impression created being rather one of brilliance and charm. Also, purple has a precious image and was used in the past in Japan as a sign of nobility. Even now it has not lost that noble, elegant, and eminent quality. When combined with colors of a red-purple hue, it has an alluring feel, and with black it gives an impression of eminence.

P

P/B
Lavender

Widely used in...

Fashion
Interior Design ★
Product Design
Visual Media ★★★

Lifestyle...

Casual
Elegant

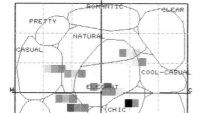

Typical Color Combination Images

glossy·······································★

refined, sleek, brilliant, colorful, alluring, modern, pure and elegant, amusing

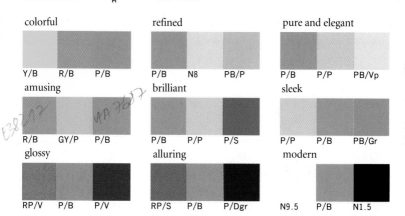

colorful
Y/B R/B P/B

refined
P/B N8 PB/P

pure and elegant
P/B P/P PB/Vp

amusing
R/B GY/P P/B

brilliant
P/B P/P P/S

sleek
P/P P/B PB/Gr

glossy
RP/V P/B P/V

alluring
RP/S P/B P/Dgr

modern
N9.5 P/B N1.5

Although lavender is technically a bright tone, it has neither the brightness nor clearness of rose, although it does retain the sparkle and gaiety characteristic of the bright tones. This shade is named after the fragrant lavender flow-er and evokes the gracefulness of lavender flowers in full bloom. When combining it with other colors, the aim should be to produce a soft effect whenever possible, in order not to spoil its beauty.

P/P
Lilac

Widely used in...

Fashion
Interior Design ★
Product Design
Visual Media ★★

Lifestyle.

Elegant
Romantic

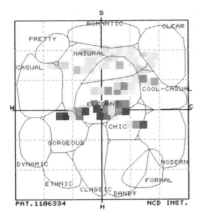

Typical Color Combination Images

pure and elegant ·········· ★★★
feminine ···················· ★★★
emotional ·················· ★★
pure and simple ············ ★★
sweet and dreamy ··········· ★★
brilliant ··················· ★
tender ····················· ★
sleek ····················· ★
fascinating ················ ★

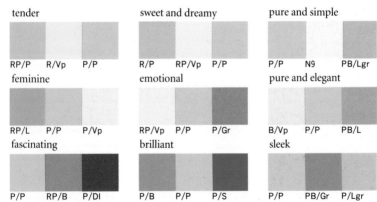

tender
RP/P R/Vp P/P

sweet and dreamy
R/P RP/Vp P/P

pure and simple
P/P N9 PB/Lgr

feminine
RP/L P/P P/Vp

emotional
RP/Vp P/P P/Gr

pure and elegant
B/Vp P/P PB/L

fascinating
P/P RP/B P/Dl

brilliant
P/B P/P P/S

sleek
P/P PB/Gr P/Lgr

No other shade conveys an image of purity and elegance more successfully than lilac. For this reason, it is often used for Japanese clothes, and its feminine feel appeals to Japanese women who live a simple and quiet life in the city. Lilac possesses sweet, dreamy, and tender qualities and is often used in fashion.

To create images that are emotional, pure, simple, sweet, dreamy, and tender, this shade should be combined with very pale tones. Alternatively, mixing it with red-purple or purple shades gives a fascinating and brilliant effect.

P/Vp
Pale Lilac

Widely used in...

Fashion
Interior Design
Product Design
Visual Media

Lifestyle...

Romantic
Elegant

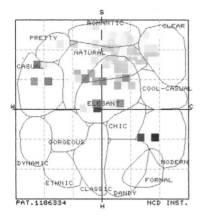

Typical Color Combination Images

romantic	★★★
dreamy	★★
soft	★★
delicate	★★
sweet and dreamy	★★
subtle	★★
feminine	★★
cultured	★★
tender	★
elegant	★

soft

| R/Lgr | P/Vp | BG/Vp |

romantic

| P/Vp | Y/Vp | B/Vp |

tender

| N8 | P/Vp | B/Vp |

sweet and dreamy

| YR/P | RP/P | P/Vp |

cultured

| RP/Lgr | P/Vp | P/Lgr |

dreamy

| BG/Vp | P/Vp | PB/Lgr |

feminine

| RP/L | P/Vp | P/P |

delicate

| P/Vp | N7 | GY/Lgr |

subtle

| P/Vp | P/Lgr | PB/Lgr |

For Japanese people, clear pastel shades tend to have a romantic, dreamy, and feminine image. It is easy to project a soft effect with pale lilac, provided that strong contrasting colors are avoided.

It takes on a dreamy, delicate feel when combined with cool colors, while with warm colors it conveys a sweet, dreamy, and tender impression. Also, by using this shade with other tones of purple, a feminine, elegant atmosphere can be created.

P

P/Lgr
Starlight Blue

Widely used in...

Fashion
Interior Design ★
Product Design
Visual Media

Lifestyle...

Elegant
Chic

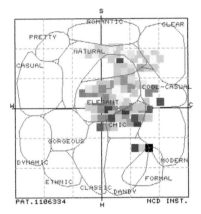

PAT.1106334

NCD INST.

Typical Color Combination Images

subtle··· ★★★
delicate·· ★★★
cultured··· ★★★
elegant··· ★★
sedate·· ★★
noble·· ★★
chic··· ★★
gentle and elegant······························· ★★
feminine, graceful································ ★
calm, noble and elegant·························· ★
interesting··· ★

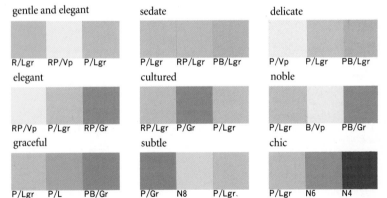

gentle and elegant

| R/Lgr | RP/Vp | P/Lgr |

sedate

| P/Lgr | RP/Lgr | PB/Lgr |

delicate

| P/Vp | P/Lgr | PB/Lgr |

elegant

| RP/Vp | P/Lgr | RP/Gr |

cultured

| RP/Lgr | P/Gr | P/Lgr |

noble

| P/Lgr | B/Vp | PB/Gr |

graceful

| P/Lgr | P/L | PB/Gr |

subtle

| P/Gr | N8 | P/Lgr. |

chic

| P/Lgr | N6 | N4 |

As this light grayish tone has only a hint of purple, the best way to bring out its delicate, subtle character is to use it in a gradation of similar shades. In this way, a wide range of images can be created—cultured, sedate, elegant, noble, and chic.

When it is combined with a warm shade, a sense of gentle elegance emerges, while combinations with a pale shade of purple give a graceful impression. The color also goes well with gray. It appeals to people who are reserved in character and dislike vulgarity.

P

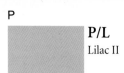

P/L
Lilac II

Widely used in....
Fashion
Interior Design
Product Design
Visual Media ★★

Lifestyle...
Elegant

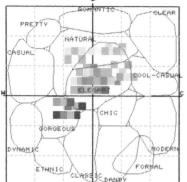

PAT. 1106334 NCD INST.

Typical Color Combination Images

graceful·································· ★★★★
elegant··································· ★★★
brilliant·································· ★
tender···································· ★
fashionable······························ ★
interesting······························ ★
feminine·································· ★

emotional, pure and simple, refined,
pleasant, glossy, fascinating

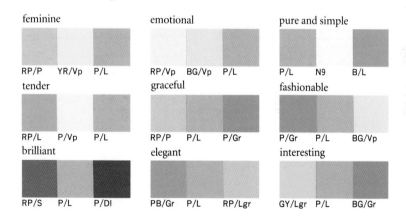

feminine

RP/P YR/Vp P/L

emotional

RP/Vp BG/Vp P/L

pure and simple

P/L N9 B/L

tender

RP/L P/Vp P/L

graceful

RP/P P/L P/Gr

fashionable

P/Gr P/L BG/Vp

brilliant

RP/S P/L P/Dl

elegant

PB/Gr P/L RP/Lgr

interesting

GY/Lgr P/L BG/Gr

The French song "When the Lilacs are in Bloom" not withstanding, the traditional Japanese name for this color (dove-feather purple) conveys an extremely elegant image. It has both a tender and fashionable feel and creates a romantic atmosphere. This shade of lilac is pure, simple and refined, and can be used to project femininity. The combination with a cool blue or a yellow gives an intriguing effect. Lilac creates a lyrical mood, inviting the human spirit to dream.

P

P/Gr
Pigeon

Widely used in...

Fashion
Interior Design
Product Design
Visual Media

lifestyle...

Elegant
Chic

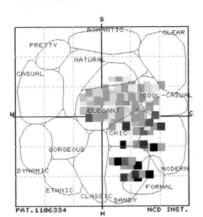

Typical Color Combination Images

fashionable, sedate ·································· ★★★
refined, sleek ······································· ★★★
graceful, elegant ···································· ★★
Japanese, subtle and mysterious ··········· ★★
subtle, polished ···································· ★★
noble and elegant, aristocratic ············· ★★
solemn, distinguished ·························· ★
sober, chic ··· ★
cultured ·· ★

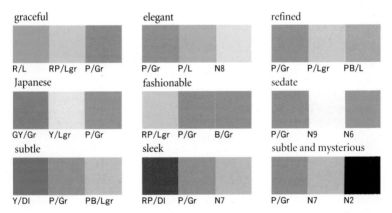

graceful
R/L RP/Lgr P/Gr

elegant
P/Gr P/L N8

refined
P/Gr P/Lgr PB/L

Japanese
GY/Gr Y/Lgr P/Gr

fashionable
RP/Lgr P/Gr B/Gr

sedate
P/Gr N9 N6

subtle
Y/Dl P/Gr PB/Lgr

sleek
RP/Dl P/Gr N7

subtle and mysterious
P/Gr N7 N2

This shade was well suited to the aesthetic sensibilities of eighteenth-century Japan, where its faint hue was probably appreciated for the atmosphere of tranquility it evokes. This color also has fashionable, sedate qualities. As a culture becomes more sophisticated, people start to demand a subtlety in materials and colors, and it may be for this reason that the quiet and subdued tone of this shade appeals to many young people.

Combining it with a hard gray or black gives a subtle and mysterious effect, while with gentle tones it has a graceful, refined, and sleek appearance.

PAT. 1106334 NCD INST.

P

P/Dl
Dusty Lilac

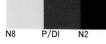

Widely used in...
Fashion
Interior Design
Product Design
Visual Media ★★

Lifestyle...
Classic
Chic

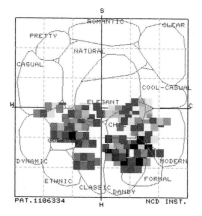

PAT. 1106334 NCD INST.

Typical Color Combination Images

stylish··· ★★★★
eminent, aristocratic······················· ★★★
distinguished, noble and elegant··········· ★★
ethnic, brilliant································ ★★
precious, sublime······························ ★★
alluring, mysterious························· ★★
complex·· ★★
luxurious, colorful····························· ★
graceful, fashionable························ ★
interesting, festive····························· ★
fascinating, decorative···················· ★
cultivated·· ★

stylish

Y/L P/Dl N7

brilliant

RP/S P/L P/Dl

ethnic

R/P P/Dl GY/Dl

distinguished

BG/Gr N8 P/Dl

aristocratic

P/Dl PB/Gr PB/Dk

precious

N5 N1.5 P/Dl

noble and elegant

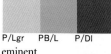

P/Lgr PB/L P/Dl

eminent

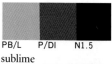

PB/L P/Dl N1.5

sublime

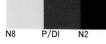

N8 P/Dl N2

This dull tone is located in the middle of the image scale and on its own has an elegant image.

Combined with light gray or blue, it also gains a feeling of purity, creating a stylish and distinguished effect. With black or dark gray, dusty lilac suggests a sublime, eminent, precious feeling.

A brilliant and alluring appearance can be created by combining this shade with warm contrasting colors, but care should be taken over the relative areas covered by each color as contrasting colors are best used as an accent in order to avoid too heavy an effect.

P

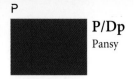

P/Dp
Pansy

Widely used in...
Fashion
Interior Design
Product Design
Visual Media ★

Lifestyle...
Classic

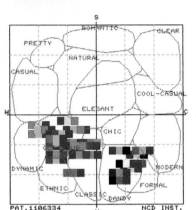

Typical Color Combination Images

gorgeous	★★★
precious	★★
luxurious	★★
mellow	★★
alluring	★★
extravagant	★★
eminent	★★
brilliant	★
colorful	★
fascinating	★
decorative	★

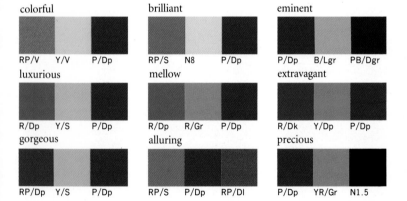

colorful
RP/V Y/V P/Dp

brilliant
RP/S N8 P/Dp

eminent
P/Dp B/Lgr PB/Dgr

luxurious
R/Dp Y/S P/Dp

mellow
R/Dp R/Gr P/Dp

extravagant
R/Dk Y/Dp P/Dp

gorgeous
RP/Dp Y/S P/Dp

alluring
RP/S P/Dp RP/Dl

precious
P/Dp YR/Gr N1.5

Pansy is a deep tone with the strong dull character typical of all the purples, and when mixed with warm colors it takes on a mellow and substantial appearance. To bring out its colorful quality, it can be combined with gold and red as shown below; this conveys a fascinating and alluring impression. Because pansy has a gorgeous feeling and can be rather rich, it sometimes takes on a vulgar, though admittedly very human, appearance. It was at one time widely used in red-light districts, but now it is seen more in amusement areas.

127

P

P/Dk

Prune

Widely used in...

Fashion
Interior Design
Product Design
Visual Media

lifestyle...

Classic

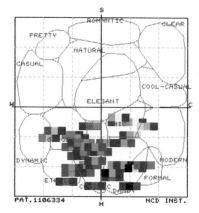

Typical Color Combination Images

majestic	★★★
mellow	★★
classic	★★
traditional	★★
elaborate	★★
tasteful	★★
sublime	★
modest	★
decorative	★
extravagant	★
complex	★

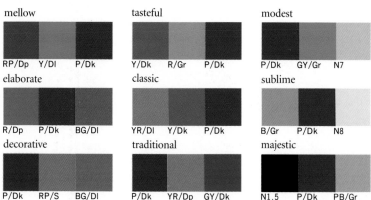

mellow

RP/Dp Y/Dl P/Dk

tasteful

Y/Dk R/Gr P/Dk

modest

P/Dk GY/Gr N7

elaborate

R/Dp P/Dk BG/Dl

classic

YR/Dl Y/Dk P/Dk

sublime

B/Gr P/Dk N8

decorative

P/Dk RP/S BG/Dl

traditional

P/Dk YR/Dp GY/Dk

majestic

N1.5 P/Dk PB/Gr

As purple becomes harder in tone, it loses a little of its graceful and refined quality, instead developing a classic, traditional, mellow appearance. However, no matter which shade prune is combined with, it always retains its hard character.

With warm-hard colors it gives a classic and ethnic impression, and its elaborate feel can be used to project a substantial image.

With cool-hard colors, the image conveyed is modest, but also sublime and majestic.

P

P/Dgr
Dusky Violet

Widely used in...
Fashion
Interior Design
Product Design
Visual Media

Lifestyle...
Dandy
Classic

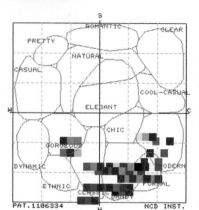

PAT.1106334

NCD INST.

Typical Color Combination Images

serious ·· ★★
masculine ·· ★
sturdy ·· ★

solemn, dignified, conservative, modern, rational, alluring

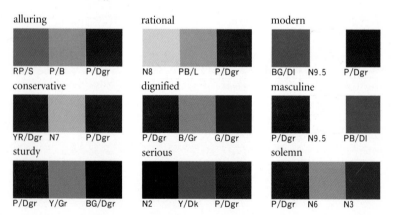

alluring
RP/S | P/B | P/Dgr

rational
N8 | PB/L | P/Dgr

modern
BG/Dl | N9.5 | P/Dgr

conservative
YR/Dgr | N7 | P/Dgr

dignified
P/Dgr | B/Gr | G/Dgr

masculine
P/Dgr | N9.5 | PB/Dl

sturdy
P/Dgr | Y/Gr | BG/Dgr

serious
N2 | Y/Dk | P/Dgr

solemn
P/Dgr | N6 | N3

Purple has an unusual, precious appearance but it does not give a sporty impression, like dark blue. Dark gray tones have a slightly uncanny feel; despite their sturdy appearance, they create an enigmatic atmosphere that is alluring, solemn, and mysterious.

Dusky violet can be combined with cool-hard colors and white used as a separating color. This shade has some unique qualities, and the images it conveys (modern, rational, etc.) differ from the effects produced by other shades of purple hue.

RP

RP/V

Magenta

Widely used in...

Fashion
Interior Design
Product Design
Visual Media ★★

Lifestyle...

Casual

Typical Color Combination Images

provocative ·································· ★★★★
tropical ·································· ★★★★
showy, vivid ·································· ★★★
colorful, flamboyant ·································· ★★★
fiery, dazzling ·································· ★★★
intense, dynamic ·································· ★★
fascinating, glossy ·································· ★★
striking ·································· ★★
bold, brilliant ·································· ★
mysterious ·································· ★

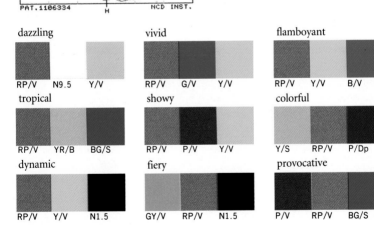

dazzling
RP/V N9.5 Y/V

vivid
RP/V G/V Y/V

flamboyant
RP/V Y/V B/V

tropical
RP/V YR/B BG/S

showy
RP/V P/V Y/V

colorful
Y/S RP/V P/Dp

dynamic
RP/V Y/V N1.5

fiery
GY/V RP/V N1.5

provocative
P/V RP/V BG/S

This shade is popular in Europe and America, as it looks good on white skin. Men find magenta dresses attractive because they create a fascinating and provocative effect. Magenta produces a dazzling and flamboyant impact when combined with orange or yellow. With black or blue a dynamic and tropical image is achieved. This kind of shade has a fiery glow, that is both captivating and sexy. Even in Japan, in comparison with vermilion, crimson is charged with emotion.

RP/S
Spinner Red

Widely used in...		Lifestyle...
Fashion	★	Casual
Interior Design	★	Classic
Product Design		
Visual Media	★★★	

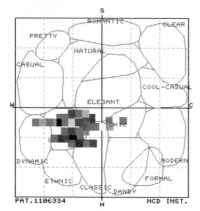

Typical Color Combination Images

alluring ···································· ★★★
mysterious ································· ★★★
brilliant ······································ ★★
decorative ·································· ★★
glossy ··· ★
Western ······································ ★
complex ······································ ★

amusing, abundant

abundant

R/V YR/V RP/S

brilliant
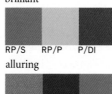
RP/S RP/P P/Dl

Western
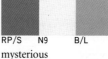
RP/S N9 B/L

glossy

RP/B P/V RP/S

alluring
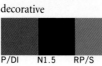
RP/V P/Dp RP/S

mysterious
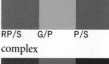
RP/S G/P P/S

amusing

RP/S Y/V P/V

decorative

P/Dl N1.5 RP/S

complex
P/Dl RP/S B/Dp

The touch of magenta in spinner red makes it a seductive and mysterious color. When mixed with red-purple or purple shades, the alluring and brilliant quality of the color emerges. With the purple and blue range of colors, it takes on a glossy and decorative feel.

Although strong tones have a substantial quality, they are rather rich and care should be taken in choosing combinations in order not to detract from their stylish effect. When combined with white or soft colors spinner red conveys a refreshing impression.

RP

RP/B
Rose Pink

Widely used in...

Fashion	★★
Interior Design	★
Product Design	★★★
Visual Media	★★★★

Lifestyle...

Casual

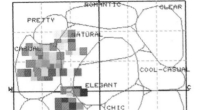

Typical Color Combination Images

amusing	★★★
cute	★★★
enjoyable	★★★
happy	★★
merry	★★
childlike	★★
pretty	★
colorful	★
fascinating	★

cute

RP/B Y/P BG/B

amusing

YR/B G/P RP/B

childlike

RP/B Y/P B/P

happy

RP/B P/Vp R/V

merry

RP/B YR/B GY/V

pretty

RP/B Y/Vp PB/B

fascinating

P/P RP/B P/Dl

colorful

RP/B BG/B P/V

enjoyable

GY/P RP/B PB/S

Rose pink is identified with romance and creates a fascinating and beautiful impression. This bright tone radiates an atmosphere of precious beauty, like jewelry, and goes well with pure colors.

In combination with vivid, bright, and pale tones, it can project a cute, merry, and enjoyable image. As it is easy to create a childlike and pretty effect with this shade, it is often used for toys and other baby products.

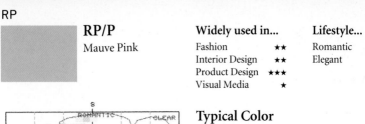

RP

RP/P
Mauve Pink

Widely used in...

Fashion	★★
Interior Design	★★
Product Design	★★★
Visual Media	★

Lifestyle...

Romantic
Elegant

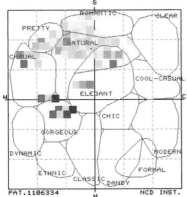

Typical Color Combination Images

charming	★★★★
sweet and dreamy	★★★★
sweet	★★★
pretty	★★
tender	★★
innocent	★★
dreamy	★★
feminine	★★
soft	★★
romantic	★
sweet-sour	★

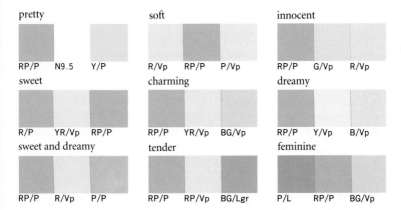

pretty

RP/P N9.5 Y/P

soft

R/Vp RP/P P/Vp

innocent

RP/P G/Vp R/Vp

sweet

R/P YR/Vp RP/P

charming

RP/P YR/Vp BG/Vp

dreamy

RP/P Y/Vp B/Vp

sweet and dreamy

RP/P R/Vp P/P

tender

RP/P RP/Vp BG/Lgr

feminine

P/L RP/P BG/Vp

Purple shades tend to be thought of as Japanese, whereas the red-purples are considered Western, even when they are very pale. This is because as the hue changes from purple to red-purple, it takes on a clearer quality. The mauve pink shown here takes its name from a flower and is a charming and tender shade.

Pink can be either red or red-purple in hue; that of a red-purple hue has a cooler quality than that of a red hue, as can be seen by comparing mauve pink (RP) with salmon pink (R). When yellow or pale red shades are combined with mauve pink the effect is innocent and pretty. The color is often used for baby products.

RP/Vp
Cherry Rose

Widely used in...

Fashion
Interior Design ★
Product Design ★★
Visual Media

Lifestyle...

Romantic
Elegant

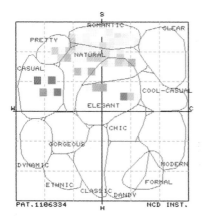

Typical Color Combination Images

agreeable to the touch·························· ★★
romantic··· ★★
sunny··· ★★
pleasant·· ★
charming·· ★
supple·· ★
innocent·· ★
gentle and elegant································ ★

emotional, soft, graceful, sweet, tender, enjoyable

agreeable to the touch

| R/Lgr | YR/Vp | RP/Vp |

supple

| RP/Vp | N9.5 | G/Vp |

romantic

| RP/Vp | N9.5 | PB/Vp |

sunny

| YR/P | Y/Vp | RP/Vp |

innocent

| RP/P | RP/Vp | Y/Vp |

charming

| RP/P | RP/Vp | B/Vp |

pleasant

| YR/Lgr | R/L | RP/Vp |

gentle and elegant

| R/Lgr | RP/Vp | P/Lgr |

emotional

| RP/Vp | BG/Vp | P/L |

Just as its name suggests, cherry rose gives a sense of being agreeable to the touch and romantic. Its silky and innocent appearance can be used to create a dreamy atmosphere. When combined with warm colors the effect is gentle, elegant, and pleasant, while cool colors bring out this color's charming quality. As the pastel shades have a childlike and cute image, they are often used for baby products or ornamental items. Care should be taken when mixing this shade with hard colors, as such colors tend to mask its softness.

RP/Lgr
Rose Mist

Widely used in...

Fashion
Interior Design ★
Product Design
Visual Media

Lifestyle...

Elegant
Romantic

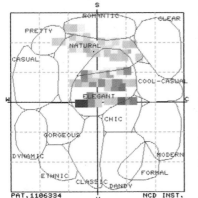

PAT. 1106334

Typical Color Combination Images

sleek ·· ★★
cultured ··· ★★
emotional ··· ★★
mild ·· ★★
refined ·· ★
graceful ··· ★
supple ··· ★
delicate ··· ★
feminine ·· ★
smooth ·· ★

mild

YR/Lgr	YR/Vp	RP/Lgr

cultured

RP/Lgr	P/Vp	P/Lgr

emotional

RP/Lgr	R/L	YR/Gr

feminine

RP/Lgr	YR/Vp	P/P

delicate

P/Vp	RP/Lgr	N7

sleek

P/Vp	RP/Lgr	P/Gr

graceful

RP/Lgr	N9	P/L

supple

YP/Vp	PB/Lgr	RP/Lgr

refined

RP/Lgr	N7	PB/Gr

This color evokes an image of mist-covered cherry blossoms in spring, and conveys a cultured, supple, sleek, and mild image. Combining it with light grayish, grayish, or very pale tones results in a pleasantly attractive mix of colors and creates a refined, graceful and delicate effect.

Rose mist cannot be described as showy or as having a refreshing appearance, but when the calmness of this tone is brought out effectively, it can give a very graceful and elegant impression. It is a beautiful shade that appeals particularly to women.

RP

RP/L
Orchid

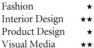

Widely used in...

Fashion ★
Interior Design ★★
Product Design ★
Visual Media ★★

Lifestyle...

Elegant

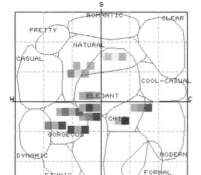

Typical Color Combination Images

graceful··★
alluring··★
glossy··★

tender, feminine, sedate, pleasant,
Western, nostalgic, sweet-sour

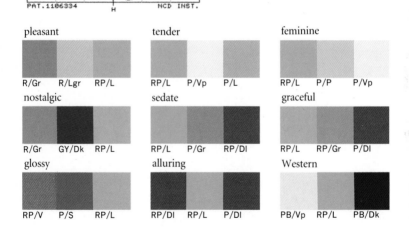

pleasant
R/Gr R/Lgr RP/L

tender
RP/L P/Vp P/L

feminine
RP/L P/P P/Vp

nostalgic
R/Gr GY/Dk RP/L

sedate
RP/L P/Gr RP/Dl

graceful
RP/L RP/Gr P/Dl

glossy
RP/V P/S RP/L

alluring
RP/Dl RP/L P/Dl

Western
PB/Vp RP/L PB/Dk

Although an elegant image is characteristic of light tones of every hue, this orchid shade is the most graceful of them all. Its natural beauty gives a pleasant, tender impression, and when combined with white or gray it creates a sedate and feminine effect.

It should not be combined with vivid, strong or hard tones, as these will detract from the elegant quality of this graceful tone. The shade cannot easily convey a clear or sporty feel.

RP/Gr
Orchid Gray

Widely used in...

Fashion
Interior Design
Product Design
Visual Media

Lifestyle..

Elegant
Chic

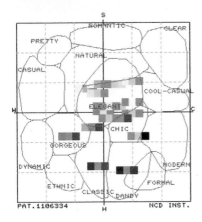

Typical Color Combination Images

elegant ·· ★
sleek ··· ★

emotional, graceful, tender, chic, subtle, mild, alluring, tender

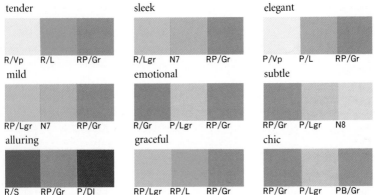

tender		
R/Vp	R/L	RP/Gr

sleek		
R/Lgr	N7	RP/Gr

elegant		
P/Vp	P/L	RP/Gr

mild		
RP/Lgr	N7	RP/Gr

emotional		
R/Gr	P/Lgr	RP/Gr

subtle		
RP/Gr	P/Lgr	N8

alluring		
R/S	RP/Gr	P/Dl

graceful		
RP/Lgr	RP/L	RP/Gr

chic		
RP/Gr	P/Lgr	PB/Gr

Grayish tones are considerably harder than very pale and light grayish ones. It is fairly easy to produce a chic or old-fashioned effect with orchid gray, but difficult to convey an elegant or romantic impression with it. This shade has a rather faint hue, which gives it a delicate and subtle, sleek appearance.

If combined with other hard tones, it expresses a sense of modesty and conveys an emotional mood. As grayish tones have only a tinge of color and possess the qualities associated with the Japanese aesthetic of restraint and simplicity, they create a reserved atmosphere.

RP

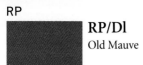

RP/Dl
Old Mauve

Widely used in..

Fashion
Interior Design ★
Product Design
Visual Media ★★

Lifestyle

Classic
Elegant

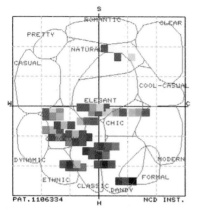

Typical Color Combination Images

alluring··· ★★
sleek··· ★★
complex··· ★★
mellow·· ★
interesting··· ★
tasteful··· ★
classic·· ★
extravagant·· ★
cultured··· ★

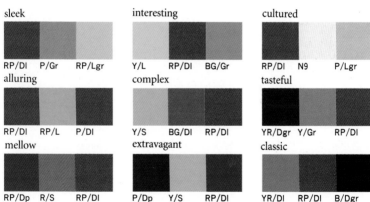

sleek

RP/Dl P/Gr RP/Lgr

alluring

RP/Dl RP/L P/Dl

mellow

RP/Dp R/S RP/Dl

interesting

Y/L RP/Dl BG/Gr

complex

Y/S BG/Dl RP/Dl

extravagant

P/Dp Y/S RP/Dl

cultured

RP/Dl N9 P/Lgr

tasteful

YR/Dgr Y/Gr RP/Dl

classic

YR/Dl RP/Dl B/Dgr

This dull red-purple tone has a stronger hue than the grayish tones, and creates an alluring, mellow effect. It is not as heavy as the deep tones.

Also, because old mauve contains more red than the purple group, it is more mellow in feel and has a tasteful and substantial image. When combined with gold and used in the packaging of luxury goods, it conveys a full-bodied impression. This shade also works well for gift items.

RP

RP/DP
Wine

Widely used in...

Fashion	★
Interior Design	
Product Design	
Visual Media	★

Lifestyle...
Classic

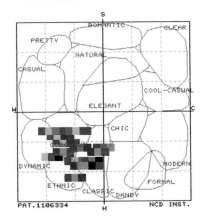

Typical Color Combination Images

gorgeous ··········· ★★★
luxurious ··········· ★★
extravagant ········· ★★
mellow ············· ★
mature ············· ★
decorative ·········· ★

elaborate, classic, ethnic, alluring, glossy, diligent

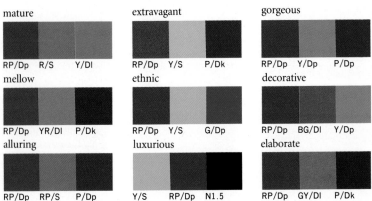

mature — RP/Dp R/S Y/Dl
extravagant — RP/Dp Y/S P/Dk
gorgeous — RP/Dp Y/Dp P/Dp
mellow — RP/Dp YR/Dl P/Dk
ethnic — RP/Dp Y/S G/Dp
decorative — RP/Dp BG/Dl Y/Dp
alluring — RP/Dp RP/S P/Dp
luxurious — Y/S RP/Dp N1.5
elaborate — RP/Dp GY/Dl P/Dk

Many shops in Bordeaux, France, have wine-colored exterior decoration, and this reinforces Bordeaux's image as a wine-producing region. This color has a gorgeous feel to it.

As wine is much richer than the dull shades, it projects a strong impression of maturity. The significant regional influence in this color helps to create a glossy and elaborate effect. It often conveys an ethnic image and is also a popular color for knitwear.

139

RP

RP/Dk
Red Grape

Widely used in...
Fashion
Interior Design
Product Design
Visual Media

Lifestyle...
Classic
Dandy

Typical Color Combination Images

mature ·· ★★
elaborate ·· ★★
substantial ·· ★★
tasteful ·· ★

mellow, old-fashioned, gorgeous, strong
and robust, classic, majestic

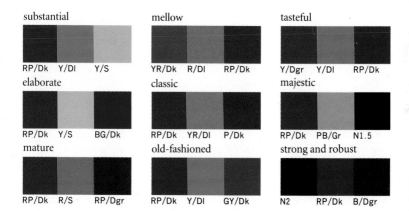

substantial

| RP/Dk | Y/Dl | Y/S |

mellow

| YR/Dk | R/Dl | RP/Dk |

tasteful

| Y/Dgr | Y/Dl | RP/Dk |

elaborate

| RP/Dk | Y/S | BG/Dk |

classic

| RP/Dk | YR/Dl | P/Dk |

majestic

| RP/Dk | PB/Gr | N1.5 |

mature

| RP/Dk | R/S | RP/Dgr |

old-fashioned

| RP/Dk | Y/Dl | GY/Dk |

strong and robust

| N2 | RP/Dk | B/Dgr |

Compared to the deep tones, the dark tones have a more concentrated hue and an even harder appearance. They convey a tasteful, classic, and majestic impression. Hue also influences the character of these dark shades: whereas PB/Dk, the dark tone of purple blue, has a strongly built, solid, and serious image,

the dark tone of red purple has an aloof and fascinating feel, although it can express traditional values too.

When red grape is combined with warm colors, a gorgeous image can easily be created, while with soft gray shades, it has a classic and dandy look.

RP/Dgr
Taupe Brown

Widely used in...

Fashion
Interior Design
Product Design
Visual Media

Lifestyle...

Dandy
Classic

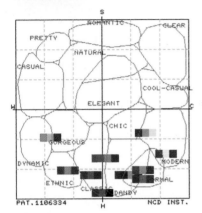

Typical Color Combination Images

intrepid··★

solemn, heavy and deep, luxurious,
mature, majestic, serious, sturdy, rustic

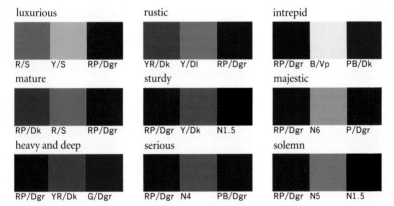

luxurious
R/S	Y/S	RP/Dgr

rustic
YR/Dk	Y/Dl	RP/Dgr

intrepid
RP/Dgr	B/Vp	PB/Dk

mature
RP/Dk	R/S	RP/Dgr

sturdy
RP/Dgr	Y/Dk	N1.5

majestic
RP/Dgr	N6	P/Dgr

heavy and deep
RP/Dgr	YR/Dk	G/Dgr

serious
RP/Dgr	N4	PB/Dgr

solemn
RP/Dgr	N5	N1.5

The red-purple hue is subdued in this dark grayish tone, the overall impression being one of darkness, with an intrepid feel. In former days, this shade was used for clothes worn by samurai.

At night, when viewed under an artificial light, taupe brown is attractive because of its sound, substantial, serious, even solemn air. However, it is not too formal and has a mature charm, conveying a feeling of authenticity. Although it is dignified, heavy and deep, this shade manages to avoid being overauthoritative.

Neutral

N9.5
White

Widely used in...

Fashion	★★★★
Interior Design	★★★★
Product Design	★★★★
Visual Media	★★★★

Lifestyle...

Modern
Casual
Romantic

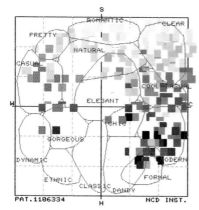

Typical Color Combination Images

crystalline, clear	★★★★★
pure, neat	★★★★★
festive, simple	★★★★★
clean and fresh, clean	★★★★★
agile, speedy	★★★★★
refreshing	★★★★★
light, fresh and young	★★★★
youthful, sporty	★★★★
proper	★★★★
sharp, smart	★★★
bright, Western	★★★
fresh, romantic	★★★

romantic *

RP/Vp	N9.5	G/Vp

clear

BG/P	N9.5	B/Vp

crystalline

BG/P	N9.5	PB/B

festive

R/V	N9.5	Y/V

simple

N8	N9.5	PB/L

youthful

Y/P	N9.5	G/B

sporty

R/V	N9.5	PB/Dp

fresh

GY/B	N9.5	PB/B

sharp

BG/V	N9.5	N1.5

White is a clear and simple color that projects a crystalline and refreshing image. When combined with yellow or red, it expresses a festive feeling. A sporty tricolor is achieved by the combination of red, white, and navy blue. If the unique properties of white are skillfully used, it is easy to create warm-soft and cool-soft color combinations. However, as white reflects puri-

ty, it is difficult for it to convey those images in the elegant zone in the middle of the image scale.

* This sample color combination was selected because it shows the wide range covered by this image.

Neutral

N 9
Pearl Gray

Widely used in...

Fashion
Interior Design ★★
Product Design ★★★★
Visual Media

Lifestyle...

Modern
Romantic
Natural
Elegant

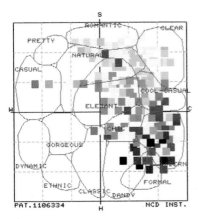

Typical Color Combination Images

dry, noble	★★★
quiet, composed	★★
polished, urban	★★
pure and simple, light	★★
cultured, sedate	★★
metallic	★★
emotional, refined	★
stylish, plain	★
supple, delicate	★
sharp, precise	★
distinguished, gentle	★
rational, formal	★

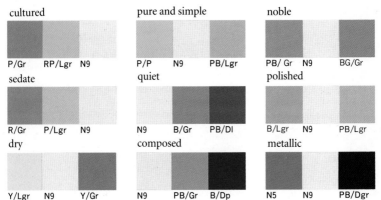

cultured
P/Gr RP/Lgr N9

pure and simple
P/P N9 PB/Lgr

noble
PB/ Gr N9 BG/Gr

sedate
R/Gr P/Lgr N9

quiet
N9 B/Gr PB/Dl

polished
B/Lgr N9 PB/Lgr

dry
Y/Lgr N9 Y/Gr

composed
N9 PB/Gr B/Dp

metallic
N5 N9 PB/Dgr

When a hint of shade is added to white, the image projected by white suddenly changes. With pearl gray, the freshness of white is reduced and a noble and polished impression is conveyed. It is difficult to mix pearl gray with warm colors; the ideal combination is with cool and soft colors.

On the other hand, as pearl gray has a dry image, it also creates a slightly metallic impression. As the color combinations consist mainly of cool tones, they reflect quietness, purity, and simplicity. However, all of the color combinations convey an overriding impression of urbane coolness.

Neutral
N 8
Silver Gray

Widely used in..

Fashion	★★★
Interior Design	★★★
Product Design	★★★★
Visual Media	

Lifestyle...

Chic
Elegant
Modern

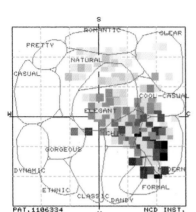

Typical Color Combination Images

intellectual	★★★
refined, sober	★★
distinguished, rational	★★
quiet, modern	★★
chic, simple, quiet and elegant	★★
sublime, precise	★★
light, Japanese	★★
dewy, aqueous	★★
calm, progressive	★
supple, delicate	★
subtle, elegant	★
composed, metallic	★

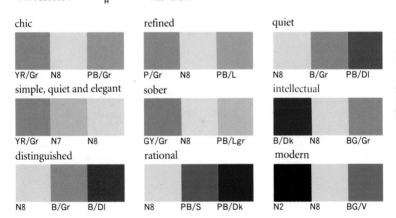

chic — YR/Gr N8 PB/Gr
refined — P/Gr N8 PB/L
quiet — N8 B/Gr PB/Dl
simple, quiet and elegant — YR/Gr N7 N8
sober — GY/Gr N8 PB/Lgr
intellectual — B/Dk N8 BG/Gr
distinguished — N8 B/Gr B/Dl
rational — N8 PB/S PB/Dk
modern — N2 N8 BG/V

The image patterns conveyed by silver gray are very similar to those of pearl gray (N9), but it has less of a cool-soft quality, and the refreshing touch is lost. It is difficult to combine this shade with clear colors, but the tone effects achieved by using it with cool colors create a reserved, refined, and distinguished image. Silver gray has an intellectual, rational, modern feeling. It can create an impression of simple, quiet elegance, with a touch of the sublime. Color combinations using this shade have a calm quality that appeals to the Japanese.

Neutral

N 7
Silver Gray II

Widely used in...		Lifestyle...
Fashion	★★	Chic
Interior Design	★	Elegant
Product Design	★★★	Modern
Visual Media	★	

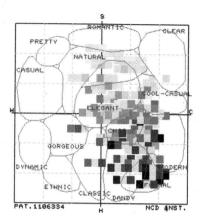

PAT. 1106334 NCD ANST.

Typical Color Combination Images

sober, earnest·· ★★
chic, tranquil··· ★★
subtle, elegant·· ★★
simple, quiet and elegant, dry···················· ★★
simple and appealing, metallic···················· ★★
aqueous··· ★★
quiet, subtle and mysterious ······················· ★
plain, progressive·· ★
delicate, sedate··· ★
mild, peaceful··· ★
rational, authoritative····································· ★
modest, sleek·· ★

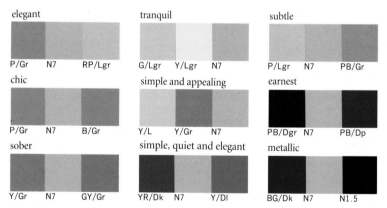

elegant

P/Gr N7 RP/Lgr

chic

P/Gr N7 B/Gr

sober

Y/Gr N7 GY/Gr

tranquil

G/Lgr Y/Lgr N7

simple and appealing

Y/L Y/Gr N7

simple, quiet and elegant

YR/Dk N7 Y/Dl

subtle

P/Lgr N7 PB/Gr

earnest

PB/Dgr N7 PB/Dp

metallic

BG/Dk N7 N1.5

The atmosphere created by this shade is that of standing peacefully in a bare field under a cloudy winter sky. The impression of moisture given by the previous shade is lost and replaced by a dry feeling. It also has a more sober quality. The chic effects of shades with no hue is particularly appreciated by the Japanese, who recognize their tranquil, simple and appealing

qualities and the subtle nuances they can convey. The image projected by this shade is harder than that of N8 and appeals to the Japanese aesthetic of simplicity and restraint. However the effect may be lost by overusing warm colors with it, and better results are achieved through combinations with other grayish tones.

N

Neutral
N 6
Medium Gray

Widely used in...

Fashion	★★★
Interior Design	★★
Product Design	★★★
Visual Media	★★

Lifestyle...

Chic
Modern
Elegant

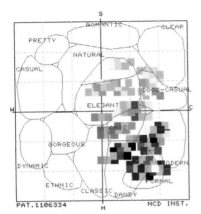

PAT.1106334

NCD INST.

Typical Color Combination Images

solemn	★★
provincial	★★
modest	★★
intellectual	★
masculine	★
simple, quiet and elegant	★
sublime	★
simple and appealing	★
formal	★
proper	★

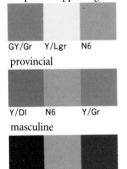

simple and appealing — GY/Gr Y/Lgr N6
provincial — Y/Dl N6 Y/Gr
masculine — GY/Dgr N6 B/Dl

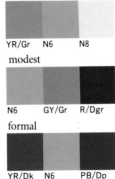

simple, quiet and elegant — YR/Gr N6 N8
modest — N6 GY/Gr R/Dgr
formal — YR/Dk N6 PB/Dp

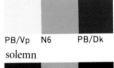
intellectual — PB/Vp N6 PB/Dk

solemn — PB/Dgr N6 N2

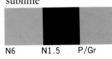
sublime — N6 N1.5 P/Gr

Although this shade is even duller in feel, it retains a delicate quality. Medium gray suggests a simple but appealing provincial world and also conveys a solemn and modest atmosphere. With black, it has an intellectual, sublime feel.

Subtle color combinations can be created by using medium gray with the grayish or dull tones. Sober and calm, this shade conveys a simple, quiet, chic image.

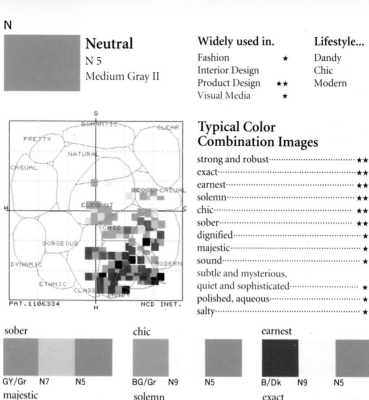

N

Neutral
N 5
Medium Gray II

Widely used in.

Fashion	★
Interior Design	
Product Design	★★
Visual Media	★

Lifestyle...

Dandy
Chic
Modern

Typical Color Combination Images

strong and robust	★★
exact	★★
earnest	★★
solemn	★★
chic	★★
sober	★★
dignified	★
majestic	★
sound	★
subtle and mysterious, quiet and sophisticated	★
polished, aqueous	★
salty	★

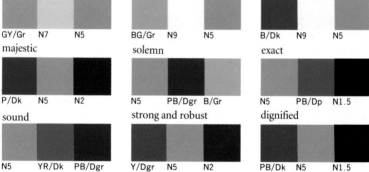

sober			chic			earnest		
GY/Gr	N7	N5	BG/Gr	N9	N5	B/Dk	N9	N5

majestic			solemn			exact		
P/Dk	N5	N2	N5	PB/Dgr	B/Gr	N5	PB/Dp	N1.5

sound			strong and robust			dignified		
N5	YR/Dk	PB/Dgr	Y/Dgr	N5	N2	PB/Dk	N5	N1.5

The color combination patterns for N5 are concentrated in the cool-hard section. Its location on the image scale means that it has a rather hard image. Therefore, in combinations with other colors without hue its image gradually changes; for example, from chic to sober and from subtle and mysterious to solemn. When a touch of brown is added, it projects a sound impression, while with the cool group of colors an exact feel emerges. For the Japanese, this shade evokes a winter landscape.

Neutral

N 4
Smoke Gray

Widely used in.

Fashion	★★
Interior Design	
Product Design	★★★
Visual Media	★

Lifestyle...

Dandy
Chic
Modern

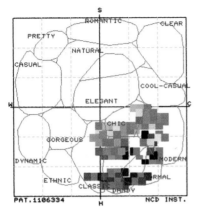

Typical Color Combination Images

subtle and mysterious	★★★
serious	★★
exact	★★
formal	★★
diligent	★★
chic	★
urban	★
provincial	★
precise	★
strong and robust	★
proper	★
bitter	★

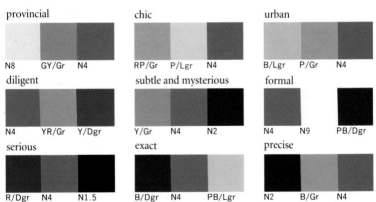

provincial
N8 · GY/Gr · N4

chic
RP/Gr · P/Lgr · N4

urban
B/Lgr · P/Gr · N4

diligent
N4 · YR/Gr · Y/Dgr

subtle and mysterious
Y/Gr · N4 · N2

formal
N4 · N9 · PB/Dgr

serious
R/Dgr · N4 · N1.5

exact
B/Dgr · N4 · PB/Lgr

precise
N2 · B/Gr · N4

Light gray is soft and elegant and appeals to the French. Dark gray is strong and robust and appeals to the Germans. This was the conclusion I came to while looking at the buildings in Paris and Berlin.

This dark gray shade conveys an image of diligence and precision. Although dark gray and light gray differ in that one is considered chic and the other metallic, both are city colors.

Neutral
N 3
Smoke Gray II

Widely used in...

Fashion
Interior Design
Product Design ★★★
Visual Media ★

Lifestyle...

Dandy
Chic
Classic
Modern

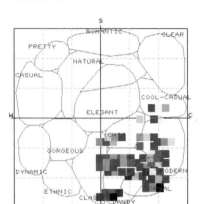

Typical Color Combination Images

solemn·· ★★
subtle and mysterious······························· ★
quiet and sophisticated···························· ★
conservative·· ★
distinguished·· ★
exact·· ★
authoritative··· ★
salty··· ★
bitter·· ★

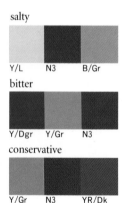
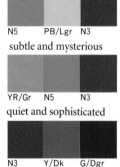
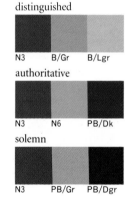

salty		
Y/L	N3	B/Gr

exact		
N5	PB/Lgr	N3

distinguished		
N3	B/Gr	B/Lgr

bitter		
Y/Dgr	Y/Gr	N3

subtle and mysterious		
YR/Gr	N5	N3

authoritative		
N3	N6	PB/Dk

conservative		
Y/Gr	N3	YR/Dk

quiet and sophisticated		
N3	Y/Dk	G/Dgr

solemn		
N3	PB/Gr	PB/Dgr

The color combinations using this shade are located mainly in the cool-hard sector of the color image scale and have a subtle, mysterious, rather solemn feel.

The shade does not work well on its own or with colors that have a strong hue. It is best used in color combinations that use a variation of tone rather than of hue, as these bring out its distinguished feel. When combined with grayish tones that have a slight hue, the effect is quiet, sophisticated, and bitter. If it is skillfully used, the shadowy nuance that differentiates this dark shade from black can produce an attractive monotone effect.

Neutral
N 2
Charcoal Gray

Widely used in

Fashion
Interior Design
Product Design ★★★★
Visual Media

Lifestyle...

Dandy
Modern
Classic

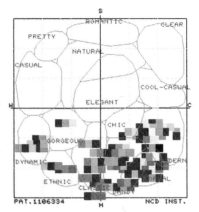

Typical Color Combination Images

intellectual·· ★★
heavy and deep·· ★★
authoritative·· ★★
formal·· ★★
subtle and mysterious, sublime················· ★
modern, composed····································· ★
sturdy, strong and robust·························· ★
dynamic and active, robust······················ ★
majestic, old-fashioned···························· ★
earnest, aristocratic································· ★
bitter·· ★

subtle and mysterious

P/Gr N7 N2

intellectual

N2 N8 B/L

formal

N2 N9 PB/Gr

old-fashioned

YR/Dk YR/Dl N2

sturdy

Y/Dgr GY/Gr N2

sublime

N2 PB/Dp B/Gr

robust

R/Dgr R/Dp N2

heavy and deep

N2 YR/Dk PB/Dgr

authoritative

PB/Dgr B/Gr N2

Dark gray is nearly black and when combined with red tones it produces a dynamic and active image. In contrast with N3, which tends to produce a cool-hard effect, N2 can be used in a wide range of warm-hard color combinations. This is because N2 has qualities attributed to both gray and black.

When combined with brown, it creates a sturdy, strong and robust feel; while with black or cool colors, it conveys an intellectual, sublime, composed impression.

Neutral
N1.5
Black

Widely used in...

Fashion	★★★★
Interior Design	★
Product Design	★★★★
Visual Media	★★★★

Lifestyle...

Modern
Casual
Dandy

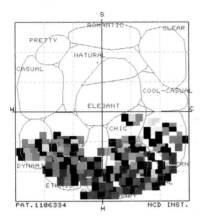

PAT.1106334 NCD INST.

Typical Color Combination Images

bold, intense	★★★★★
forceful, dynamic	★★★★★
striking, sharp	★★★★
fiery	★★★★
modern, dynamic and active	★★★
majestic, metallic	★★★
active, robust	★★★
proper, formal	★★★
authoritative, strong and robust	★★★
intrepid	★★★
heavy and deep, solemn	★★
untamed, stylish	★★

bold

R/V N1.5 Y/V

stylish *

N1.5 P/Dl B/L

modern

N1.5 B/Vp BG/V

fiery

N1.5 YR/V R/V

intense

P/V Y/V N1.5

sharp

N1.5 N9.5 PB/V

striking

RP/V N1.5 BG/V

strong and robust

YR/Dgr YR/Gr N1.5

metallic

N1.5 PB/Dl N7

Black and white convey contrasting images, and black can be used for a range of hard effects that white cannot produce. It can create many images: dynamic, old-fashioned, dapper, formal, modern. It is used in a wide variety of fields, including fashion and interior and product design. Black's main characteristics are dynamism and sharpness, and it is associated with strong feelings. It is a bold and striking color.

* This sample color combination was chosen because it shows the wide range covered by this image.

Index I

This index serves as a reference list to look up the words describing images according to their position in the image scale pattern.

As words with similar images are grouped together, this index can be used to select the words that match a desired image and the appropriate color.

→ The Combination Image Scale on p.11 and the Key Word Image Scale on p.12-13 are used as references.

→ The letters refer to the color hue and the numbers the page on which it appears.

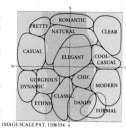

IMAGE SCALE PAT. 1106334

GORGEOUS	1	abundant R23 32 YR34 35 G78 80 RP131
	5	alluring R23 30 P119 120 127 129 RP131 136 137 138 139
	10	aromatic YR35 42 43 44 .
	15	brilliant R24 P118 119 120 121 124 126 127 RP131
	37	decorative Y47 55 G79 BG90 P118 128 RP131 139
	57	extravagant R31 Y47 55 P127 RP138 139
	58	fascinating R23 P118 121 RP132
	73	glossy R23 P118 119 120 RP131 136
	74	gorgeous Y47 55 P127 RP139
	91	luxurious R23 31 YR35 Y47 P127 RP139 141
	94	mature R23 30 Y47 GY66 67 RP139 140 141
	95	mellow R23 29 30 31 32 Y54 P127 128 RP138 139 140
	132	rich R23 31 YR35 Y47 GY67 G80
	159	substantial R32 YR44 Y47 RP140
ETHNIC	55	ethnic R31 32 Y47 55 GY59 66 68 G79 BG90 91 92 B103 P126 RP139
	133	robust R31 G80 B105 N150
	172	untamed R23 31 32 33 YR35 43 45 Y56 GY59 67 68 69 G80 BG92 93
	178	wild R33 Y55 GY66 68 G79 BG91
ROMANTIC	4	agreeable to the touch R26 27 YR39 RP134
	6	amiable R26 27 YR39 40
	18	charming R26 YR38 G74 B98 RP133 134
	45	dreamy YR38 Y50 BG86 B98 PB110 P122 RP133
	81	innocent R26 GY62 G74 RP133 134
	134	romantic B98 PB110 P122 RP134 N142
	148	soft R26 27 YR38 GY62 63 BG86 P122 RP133
	163	supple R26 27 G74 75 BG86 RP134 135
	165	sweet and dreamy R25 26 P121 122 RP133
NATURAL	22	citrus Y49 GY60 61 G74 76
	44	domestic R28 YR37 38 40 GY63 64 G75
	46	dry YR39 Y51 53 N143
	66	free YR37 Y50 GY60 61 G73
	67	fresh GY58 60 61 G71 72 73 74 76 BG88 B96 PB108 N142
	70	generous R25 28 YR39 40 Y50 GY64
	71	gentle R26 YR39 Y50 BG86
	72	gentle and elegant R27 28 29 YR40 P123 RP134
	78	healthy YR36 Y49 GY58 61 G76 BG85
	85	intimate YR37 38 39 40 Y51 52
	89	lighthearted YR36 37 GY59 61 64 G72 BG87
	98	mild R27 28 YR38 39 RP135 137
	102	natural YR40 Y51 52 GY59 63 64 67 G75 78 79
	106	nostalgic R29 30 Y53 54 RP136
	108	open YR36 Y48 49 50 GY58 G72 73 B96
	110	peaceful Y50 GY64 G75 76 77 BG87 B97 100

 135 rustic YR42 43 44 Y55 57 GY66 RP141
 156 sturdy YR43 44 45 Y56 BG93 PB117 P129 RP141 N150
 167 tasteful R30 Y56 57 GY68 P128 RP138 140
 169 traditional R32 YR42 43 45 Y56 GY65 68 69 PB117 P128

DANDY 9 aristocratic PB112 P119 126
 12 bitter Y55 56 57 G81 N149
 35 dapper Y53 57 B104 105
 42 diligent R30 YR42 Y54 GY66 69 BG92 N148
 52 eminent B99 PB116 P119 126 127
 111 placid R33 YR41 44 Y56 57 G81 BG93
 115 practical YR43 44 45 GY65 69 G79 80 B102 105
 127 quiet and sophisticated R33 YR45 Y54 56 57 GY66 68 G81 N149
 138 serious R33 Y57 GY69 BG93 P129 RP141 N148
 150 sound YR45 Y53 G79 81 N147
 155 strong and robust R33 YR45 Y57 G81 B105 PB117 RP140 N147 151
 161 subtle and mysterious YR41 Y53 GY68 PB112 P125 N148 149 150

FORMAL 11 authoritative B101 PB117 N149 150
 41 dignified R33 G80 81 B101 104 PB117 P129 N147
 49 earnest B104 PB115 116 N145 147
 65 formal PB116 N146 148 150
 92 majestic BG92 PB113 P128 RP140 141 N147
 116 precious B103 P119 126 127
 120 proper PB117
 149 solemn GY69 B101 105 PB117 P129 RP141 N146 147 149
 158 sublime B101 105 PB115 P126 128 N146 150

CLEAR 24 clean BG85 86 B97 PB109
 25 clean and fresh GY58 G71 BG84 85 B97 PB106
 26 clear G74 B97 98 PB108 N142
 31 crystalline G75 BG85 86 B96 97 98 PB108 112 N142
 68 fresh and young GY61 G73 74 76 BG85 88 B95 98 PB108
 88 light GY62 PB110
 103 neat G74 76 BG85 86 87 PB107
 123 pure BG85 86 87 B98 PB107 108 110
 125 pure and simple G73 75 B98 99 100 PB110 P121 124 N143
 130 refreshing G73 BG84 B96 98 PB107 108 109
 141 simple BG87 B95 97 PB109 112 N142

COOL- 3 agile BG82 83 B96 103 PB106 115 116
CASUAL 145 smart G77 BG83 90 91 B95 97 100 PB108 112 115
 151 speedy B94 96 PB106
 152 sporty Y46 BG82 83 B94 95 104 N142
 153 steady GY60 62 G70 71 73 BG86 88 PB107 114
 176 Western G76 BG85 88 PB114 RP131 136

Index II

This index corresponds to the data base of words describing images on p.14-17. The letters refer to the color hue and the numbers the page on which it appears.

22 citrus Y49 GY60 61 G74 76
23 classic YR42 G80 BG93 P128 RP138 140
24 clean BG85 86 B97 PB109
25 clean and fresh GY58 G71 BG84 85 B97 PB106
26 clear G74 B97 98 PB108 N142
27 colorful R24 BG84 P120 127 RP130 132
28 complex GY67 G78 BG90 RP131 138
29 composed B101 102 103 PB110 115 N143
30 conservative YR44 45 Y53 56 GY68 G81 BG92 B104 P129 N149
31 crystalline G75 BG85 86 B96 97 98 PB108 112 N142
32 cultivated BG85 88 PB114
33 cultured R27 P122 123 RP135 138 N143
34 cute R25 Y49 GY60 G73 B97 RP132

D

35 dapper Y53 57 B104 105
36 dazzling YR34 Y46 P118 RP130
37 decorative Y47 55 G79 BG90 P118 128 RP131 139
38 delicate YR38 B99 PB111 P122 123 RP135
39 delicious R30 YR34 35 36 43
40 dewy BG88 89 B99
41 dignified R33 G80 81 B101 104 PB117 P129 N147
42 diligent R30 YR42 Y54 GY66 69 BG92 N148
43 distinguished BG89 B99 101 PB109 116 P126 N144 149
44 domestic R28 YR37 38 40 GY63 64 G75
45 dreamy YR38 Y50 BG86 B98 PB110 P122 RP133
46 dry YR39 Y51 53 N143
47 dynamic R22 Y46 G70 71 RP130
48 dynamic and active R22 31 33 YR35 G70

E

49 earnest B104 PB115 116 N145 147
50 elaborate R31 32 Y54 55 GY67 BG90 91 92 P119 128 RP139 140
51 elegant R29 P123 124 125 RP137 N145
52 eminent B99 PB116 P119 126 127
53 emotional R28 29 GY62 PB110 P121 124 RP134 135 137
54 enjoyable YR34 35 Y48 GY58 G72 BG84 B96 RP132
55 ethnic R31 32 Y47 55 GY59 66 68 G79 BG90 91 92 B103 P126 RP139
56 exact BG90 92 B101 102 PB111 N147 148 149
57 extravagant R31 Y47 55 P127 RP138 139

F

58 fascinating R23 P118 121 RP132
59 fashionable G77 PB111 P124 125
60 feminine R25 YR38 P121 122 124 RP133 135 136
61 festive R22 24 GY58 N142
62 fiery RP130 N151
63 flamboyant YR34 Y46 GY58 G70 71 RP130
64 forceful R22 YR34
65 formal PB116 N146 148 150
66 free YR37 Y50 GY60 61 G73
67 fresh GY58 60 61 G71 72 73 74 76 BG88 B96 PB108 N142